The SAGINAW TRAIL

From Native American Path to Woodward Avenue

Leslie K. Pielack

THE
History
PRESS

Published by The History Press
Charleston, SC
www.historypress.com

Front cover, top: Corduroy road through the forest. *New York State Archives (NYSA_A3045_ A1694), digitalcollections.archives.nysed.gov/index.php/Detail/Object/Show/object_id/371*; bottom: Looking up Woodward Avenue, Detroit, Michigan. *Detroit Publishing Co., Library of Congress, www.loc.gov/item/2016814204.*
Back cover: Aerial view of Birmingham, 1930s. *Clyde Peabody, Photographer, Birmingham Museum, Birmingham, Michigan.*

First published 2018

Manufactured in the United States

ISBN 9781467136419

Library of Congress Control Number: 2018936092

To Larry, Drew and Dylan
and to all my friends
who understand the importance of stories

CONTENTS

CONTENTS

Preface
PEOPLE AND PATH

This book is about a path—the Saginaw Trail—but it is mostly about the people who followed the path or stopped along it to live their lives and build something for themselves and their descendants. It is their stories that are the focus of these pages. History is, of course, made up of facts, including dates and places and descriptive details of lists of events. Traditionally, these data are threaded together into a narrative to try to tell stories of the past; but it is the lament of many a schoolchild that studying facts is boring and tedious, making history and its people largely uninteresting. But instead of the facts determining what stories should be told, an alternative is to begin with the stories and let them give meaning to the facts.

Naturally, more facts are known about people who are famous and powerful, whose social status or governmental position meant that more documents and evidence are going to be available in the first place. Evidence about the poor, the worker, the disenfranchised, the unlettered is more elusive and implicit. However, in many cases, their stories in fact persist, either because of local folklore and oral traditions or cherished family narratives. Not to be confused with precise or verifiable facts, these stories provide a rich emotional context that imparts meaning, telling us what mattered to those at the time—and to the extent the stories are still told, what still matters.

As both psychotherapist and local historian, I have often been drawn to the human backdrop of historic facts and events. As a historian, I recognize that without proof or documentation, we can't say with certainty what motivations might lay behind individual behavior. But as a psychotherapist,

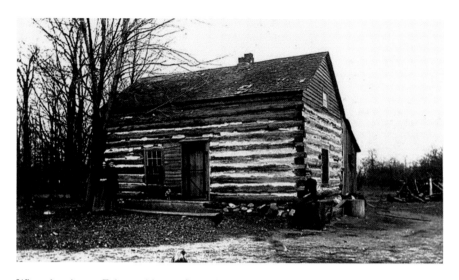

When the pioneer Fulton cabin was first built in the 1820s, it was surrounded by heavy forest just off the Saginaw Trail near what is now Eight Mile Road and Woodward. *University of Michigan, Bentley Historical Library.*

I am trained to interpret and infer based on observation and understanding of individual psychology. In this book, I have applied this perspective by presenting the historical record of the Saginaw Trail in the greater context of the human condition. I have sought to place people's behavior in relation to the cultural narrative of the times, accounting for the presence of bias in the surviving record. It must be remembered that the historical record is subject to errors and omissions because it depends on the fallible human beings who created that record. Documents can be improperly recorded, essential information forever lost to misfiling or language barriers; or unpopular notions can be suppressed or simply not recorded at all. Viewed through a more humanizing lens, we can see historical individuals in realistic human terms that make them and their world more accessible and familiar to us. This empathic connection offers a glimpse into another's experience that helps us find meaning in their story. A reader who wants to personalize the past and wonders, "What might it have been like…?" may find much appeal in this approach.

In the end, I believe it is not the Saginaw Trail or its modern manifestation as Woodward Avenue that matters as much as how its significance was shaped by the people who followed it, changed it and made it bigger than life. If we can better understand their world, we will better understand our fascination with this road and how it has become so great.

ACKNOWLEDGEMENTS

In the course of preparing this book, so many individuals and institutions have come to my aid that I regret I am not able to list them all. Each and every one has my highest regard and appreciation for all the assistance I received in researching, brainstorming, making image requests and generally asking for the almost impossible from people who were kind enough to stop what they were doing to help me. I have been saying for years now that museum and library people are "the best!" and that has been borne out in my process for this book.

Therefore, I would like to acknowledge them as a whole and honor the amazing and valuable service we, the public, receive when we undertake any effort to retrieve information about the past. We have access to really incredible historic and cultural resources and a virtual army of people poised to help—people who are passionate about their collections and want, more than anything, to share them. They include:

- LOCAL HISTORY ORGANIZATIONS AND HISTORICAL SOCIETIES: They rarely get the attention they deserve, yet they are the most important resource in preserving the stories of real people in their communities. There is one in almost every town, and they are committed to keeping their local history alive. A prime example for Oakland County is the Oakland County Pioneer and Historical Society, one of the oldest of its kind in the state and a true gem.

- LIBRARIES WITH ONLINE COLLECTIONS (especially images and documents) made freely available to the public: What a gift university libraries and public libraries give us every day just by preserving and making unique documents and images accessible, and what a national treasure we have in the Library of Congress. In Michigan, the Clarke Historical Library holds some of the most historically valuable documents of everyday people, and it is unsurpassed in its Michigan Native American materials.
- SPECIAL COLLECTIONS ONLINE GENEROUSLY SHARED WITH THE PUBLIC: Such as the David Rumsey Map Collection, which has a very cool feature allowing users to superimpose maps to make comparisons over time; and the Michigan County Histories and Atlases online collection at the University of Michigan, which has a wealth of original publications of Michigan's history available and easily searchable.

My sincere regard to these keepers of the past and to those who also keep the present, for it will be part of the past soon enough.

Introduction
OF GLACIERS AND SWAMPS

O ur modern-day northern hardwood swamps, silt marshes and bogs are only a faint reflection of the enormous tracts of swamplands that dominated northern Ohio and southern Michigan just a few centuries ago. Now mostly gone, drained by ditches or channeled below the surface, we think of the land as the dry earth below our farms, subdivisions and city streets. We seldom have reason to imagine it any other way. Yet Michigan's unique geophysical past is ever present in the landscape and has directly determined the path our state's cultural history has taken.

Europeans who first came to the area encountered a waterlogged landscape covering so many square miles in the lower Great Lakes that it was considered uninhabitable. Land travel was of little concern anyway to the French and British who came to reap the wealth of North America's fur trade in the seventeenth, eighteenth and early nineteenth centuries. Control of waterways and access to Indian trading networks were their focus; they had no need for agricultural settlement or colonization. The interior mattered only as the wilderness origin of Indian furs. European trading outposts stuck to the rivers and shores. Indigenous peoples* likewise camped along navigable rivers and lakeshores and used water routes to conduct trade with the Europeans. However, they also regularly traveled

* Throughout this book, the terms "indigenous people," "Native Americans" and "Indians" are used more or less interchangeably, "Indian/s" being the term used on many documents and sometimes used by various tribes today. Whenever possible, the name of the specific tribal group is used, e.g., "Saginaw Chippewa" and also "Anishnaabeg," or the various peoples who share culture and language in the Great Lakes region.

by foot along well-known trails and developed an intimate understanding of the interior landscape, swamps and all. This knowledge became part of their cultural traditions and was essential for life-sustaining access to natural resources.

Until the close of the Revolutionary War and transfer of the Northwest Territory to the United States, outsiders remained unconcerned with settlement of the land itself. But when the Americans came, they found the great Michigan wilderness stubbornly resistant to domestication, largely because of the great swaths of inhospitable marshy terrain and equally impenetrable forests. Yet, once tamed, that very landscape would make great fortunes many times over, securing the future of the Michigan Territory and the new nation.

POST-GLACIAL MICHIGAN

To understand the landscape challenges faced by settlement-minded Americans requires a closer look at the geological conditions that created it. The first efforts to explore the interior found great swamps and wetlands, formed by the uneven melting of the last North American ice age glacier about ten thousand years ago. It created a surface terrain in and around the Great Lakes that doesn't exist anywhere else. As mile-thick glacial ice edges advanced and retreated over and over, a series of enormous ripples, shallows and pits was created in the surface by the back-and-forth movement and massive weight of the ice. Materials scraped and carried along were deposited by uneven melting. In some areas, valleys formed with rivers that drained into large basins. These became great lakes, whose shorelines gradually retreated to where they are today. But in many parts of southern Michigan and northern Ohio, water pooled in depressions that drained only slowly or not at all. Layers of fine silt and clay accumulated in mucky shallows, and high water tables kept the land wet much of the time. Eventually, wetland plants found the environment especially friendly, depositing organic material season after season and enriching the soil. Over thousands of years, forests of water-tolerant trees like swamp oak, ash, maple, tamarack and white pine found foothold, forming great canopies that restricted sunlight and reduced evaporation over hundreds and hundreds of miles.[1] These leafy behemoths grew to hundreds of feet in

height and, when they fell with old age or storms, opened up areas where more growth could sprout in the sunlight. New ecosystems developed with a greater variety of plant and animal life, adding more organic matter. Although there were dry seasons, the conditions of moisture-holding clay soils, little or no drainage, spongy surface tree roots and low evaporation kept things…well, wet.

FINDING A WAY

The retreating glacier and lush vegetation attracted large land animals such as mastodons and mammoths and smaller herd animals such as caribou. They formed migration trails that led through ancient swamps, where their remains are sometimes found nearly intact, having perished stuck in mucky shallows.[2] The people who followed them (classified as Paleo-Indians) established trade routes along the way and left behind bi-face projectile points and other evidence of many thousands of years of use.[3] Thus, our geological history led directly to our cultural history, for it determined the route of the most historically important Indian path in Michigan: the Saginaw Trail.

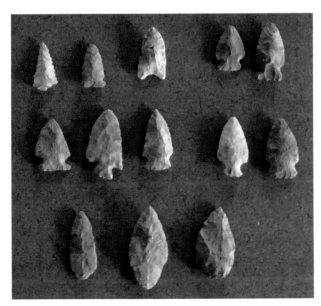

These bi-face projectile points were found along the Saginaw Trail at a trading crossroads near Birmingham used by Paleo-Indians for more than eight thousand years. *Birmingham Museum.*

The Saginaw Trail was a crucial land route used by indigenous peoples and later by pioneer settlers to navigate the forest wilderness of early Michigan. *Mills,* History of Saginaw County *(Archives.org).*

The well-used foot trail system used by Native Americans who came after Paleo-Indians was the best method for navigating the landscape, and the first American pioneers in the Michigan Territory followed these same paths to penetrate the wilderness. Indian trail routes were the arteries of transportation, industry and culture that carried people, goods and ideas back and forth across the land in ways that uniquely shaped the fate of our state. The rich soils under the old swamps and the shallow lakebeds eventually led to unrivaled agricultural production and prosperity. The forests and other natural resources yielded raw materials that led to the enrichment of privileged American elite, as well as the growth of a corresponding class of laborers and industrial workers. The many rivers provided early power for local economies, ensuring successful settlement and offering opportunities for entrepreneurs. But it was the Saginaw Trail

that was the key to gaining access to Michigan's wild country and all it had to offer. It was so significant to the settlement patterns and economic foundation of our state that it could be said that the Saginaw Trail built Michigan and was the most important reason that Detroit became the Motor City and, ultimately, the global center of the auto industry. In modern times, Woodward Avenue, often called "Michigan's Main Street," has had a dynamic energy that is in almost constant motion, reaching into Michigan and back out again into the world at large. The Woodward corridor transports people, goods and ideas today just as its predecessor, the Saginaw Trail, once did.

TALES OF THE TRAIL

In traveling the old Saginaw Trail route from Detroit through Pontiac, on to Flint, then Saginaw and beyond, an observer can still see remnants of the ancient trail coexisting with the present road. The landscape, its use, the towns' character and architecture hint at the continuum of history along the way. This book relies on the trail's physical route as an organizing principle for understanding how it changed over time and what happened to people and communities along the way. Each chapter offers some background to understand the historical context of a particular time and location; a different take on the same context may appear in another chapter. In Part I, the emphasis is on certain significant places and events on the trail and how they relate to stories of some of its people. It covers the earlier period of exploration and the establishment of community roots. Part II presents an overview of the great changes that came with the evolution of transportation and agricultural and industrial technologies and how these changes affected greater numbers of people.

This type of presentation lends itself to a nonlinear grouping of themes, events and stories rather than a historical timeline. Such narrative clusters allow a consideration of ideas as discrete vignettes, although they have threads that connect them to one another and to the Saginaw Trail. However, the scope of this book permits only a sampling of all the possible narratives that could be told and limits the depth of exploration as well. But it is hoped that readers will find these stories intriguing and will continue to explore more on their own.

This book makes the point that any understanding of what has become our iconic Woodward Avenue requires an understanding of the Saginaw Trail, and the trail's story is intimately intertwined with the people who changed it and were changed by it. It emphasizes everyday people as much as great leaders. But it leaves untold the stories of the vast majority who have lived their lives along this route, most of whom will never be known, but whose cumulative contributions tell us something about the land, the trail and the legacy we see today.

PART I

The Lure of the Trail

So deep a silence, so complete a calm prevailed in these forests....One could only hear the unwelcome buzz of mosquitoes and the noise of our horses' hoofs....At the end of an hour we came to a place where the road forked. Two paths opened there. Which to choose? The choice was crucial.

How many times during our travels have we not met honest [American] citizens who said to us of an evening, sitting peacefully by their fire: the number of the Indians is decreasing daily....This world here belongs to us, they add. God, in refusing the first inhabitants the capacity to become civilised, has destined them in advance to inevitable destruction. The true owners of this continent are those who know how to take advantage of its riches.[4]

—*Alexis de Tocqueville, "A Fortnight in the Wilds,"* Journey to America, *1831*

INTO THE WILD

The French came to the Michigan area in the seventeenth century to establish lucrative fur trade relationships with the native tribes. The British came later to move in on the French and compete for the same rich resources. Neither European interest went much further than the furs and the easiest way to procure them and make the greatest profit. As a result, even the important depot centers of Detroit and Mackinac had relatively small settlements huddled around military outposts that provided security and commercial support for the fur trade. Their seasonal populations relied mostly on shipped supplies and, to a lesser extent, on vegetables grown by local Indian tribes. The milder climate of Detroit lent itself to some sustenance farming, where a very few, mostly French, settlers managed to make a living for their families along the riverfront on narrow ribbon farms.

The interior of Michigan was wild, unknown forest for miles and miles, with a network of footpaths between Indian villages and camps and along rivers. From the point of view of the Europeans, it was the domain of native peoples and wild animals, both of whom only really mattered insofar as they provided beaver, fox and other furs. To be sure, the Indian population figured into skirmishes at frontier outposts or when they could be enlisted as allies to help fight a war for control. But as Michigan was not of interest for settlement, the native population was left largely alone, so long as it remained a valuable trading partner and sometime ally. French traders often formed family ties with local tribes for commercial gain, but

neither the French nor the British who followed wanted to bother with much more than controlling the flow of furs. This state of affairs continued for 150 years or so before the coming of the Americans, when everything abruptly changed.

ENTER THE AMERICANS

Very simply put, after the Revolutionary War, the American government had its hands full trying to stand on its own two feet. The 1783 Treaty of Paris enlarged the United States to include an enormous area—the Northwest Territory—that is now Michigan, Ohio, Indiana, Illinois, Wisconsin and Minnesota. But before the new nation could catch its breath, it faced another war with a federation of Indian tribes. The Northwest Indian War or "Little Turtle's War" of 1785–95 was an effort to resist American expansion into this land, which still belonged to the occupying tribes. This suited the British just fine; they supported the native tribes from Canada and continued to enjoy profits from the fur trade while the Americans were otherwise occupied. They also frustrated attempts by the United States to take possession of their territorial forts, ultimately delaying the transition thirteen years, when the implementation of the 1795 Jay Treaty finally settled the matter.

Meanwhile, in the remote wilderness of Michigan, there was little evidence that anything had changed. The fur trade continued according to seasonal cycles, as it always had. French-Indian familial and cultural groups continued to coexist with British citizens in the few areas of Michigan where Europeans could be found, mostly Mackinac and Detroit. The native peoples continued to supply natural resources as trading partners and received European goods in exchange. The change in governments made little difference. That is, until the Americans finally came to take what was theirs.

The official transfer of power in 1796 from the British to the Americans was duly noted by the lowering of flags and exchange of occupying troops at Forts Mackinac and Detroit. But a sense of instability persisted. The threat of the British across the river from Detroit and just miles away from Mackinac in Canada left the few Americans who were in charge ill at ease. Most of the Indian tribes in Michigan (primarily Odawa/Ottawa, Potawatomi and Ojibwe/Chippewa) had family ties to the French or financial and military ties to the British and looked at the Americans with suspicion. Commercial and

political forces within fur trade alliances increased pressure and competition for control between the old powers and the new. Ill-advised policies about the indigenous people and enactment of restrictive laws by the Americans who took over created further hostility. An uneasy peace settled around the outpost towns of Mackinac and Detroit and in the territory as a whole toward the turn of the nineteenth century. When the War of 1812 finally erupted, three long years of war and destruction ensued, driving away or devastating the small American population. This was followed by several more years of disorganized transfer of power from the recalcitrant British to the United States. The wilderness of Michigan remained an unexplored and unknown world even as late as 1816, more than thirty years after it became American territory.

When faced with its large expanse of new lands, the American government wanted to accomplish several objectives as soon as possible: 1) to understand what lay in the vast lands in terms of potential resources (furs, naturally, but also minerals and other natural resources that could be used to build government coffers); 2) to devise a means of converting the land itself into needed cash through public sale; and 3) to expand and consolidate the new nation's security to counter threats that may resurface from England, France, Spain or other foreign powers. This played out in Michigan in a way that completely upended the customary *laissez-faire* approach that had characterized European possession. Instead, the United States was prepared to muscle its way to colonize Michigan as quickly as feasible and as aggressively as necessary. Key steps were taken to

In this 1923 mural by Frederick Wiley in the Detroit Public Library, Michigan's wilderness was symbolized by the "noble Indian" and forest creatures, contrasted with presumably superior European civilization. *Burton Historical Collection, Detroit Public Library.*

ensure speedy success. A program for surveying land as scientifically and precisely as possible was begun. This led to the establishment of a system for subdividing and selling land parcels to eager Americans who would populate the wilderness and turn it into productive farms, local industries or commercial development, enriching the new nation further.[5] And to make all this work, it was necessary to continue (and expand) the policy of wresting lands away from the native peoples by treaty.

A NEW TOWN FOR THE TERRITORY

In Michigan, it was the modest city of Detroit that became the epicenter of these efforts. By 1816, Detroit was more accessible and situated more favorably than the island of Mackinac as a base for territorial expansion and colonization. Thirty-one-year-old Lewis Cass, who had distinguished himself in Detroit during the War of 1812, was appointed territorial governor in 1813 with a big job to do. To help Cass accomplish his ambitions for Michigan, he had the resources of the new federal land survey program and the military forts at Detroit and Mackinac. But even more importantly, he had a solid group of prominent, determined leaders in Detroit behind him. They included lawyers, judges, merchants and ex-military officers, including Alexander Macomb; Augustus Woodward and James Witherell; and especially William Woodbridge and Solomon Sibley.[6]

A first step toward civilizing the territory involved laying out a complete town in the forest wilderness on a large tract of former Indian land. A partnership of fifteen Detroiters invested in the Pontiac Company in November 1818 to purchase a large parcel of land for a town. It encompassed the site of a traditional summer camp of the Saginaw Chippewa (Ojibwa) tribe.[7] The spot offered a wealth of natural resources that were essential to the town's success.

Native American claim to the lands had been lost through the Treaty of 1807; however, a provision allowed them to "enjoy the privilege of hunting and fishing on the lands ceded…as long as they remain the property of the United States."[8] The tribes therefore continued to use the land as they always had, moving seasonally between camps in southern Michigan. Although this new town would be a small island surrounded by deep wilderness, its existence signaled more than a mere disruption of tribal access to traditional

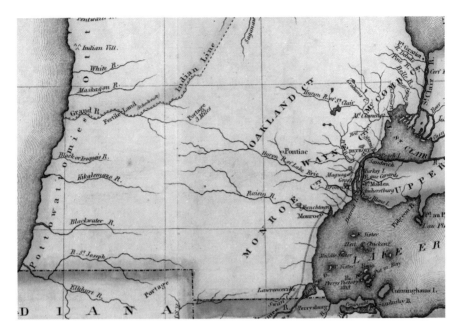

Michigan Territory was mostly an unknown wilderness in the early settlement period. Waterways and Indian trails were the main modes of travel in the interior. *David Rumsey Historical Maps.*

Indian lands. It spelled change to traditional life itself. The chosen site lay at the intersection of major east–west and north–south trails that crossed the Clinton River (then called the Huron River of St. Clair). The north–south path was an ancient one. It led from the Chippewa villages at Saginaw, south across the Flint River, over hilly forest and through lowland swamps to Detroit. This was the major route used by thousands of indigenous people to report to Detroit for annual treaty payments.

This important path was the Saginaw Trail, and the new town was to be built squarely in the middle of it. Although it was the traditional land route used by indigenous peoples for centuries, a white settlement would now occupy it. Just as native tribes would have to find a way around it to avoid the settlers, they would have to find a way to survive all the challenges brought by these Americans, who would now make the Saginaw Trail their own special road. It would bring even more migrants to the town of Pontiac and beyond, and it would no longer be the Indians' trail.

THE HERO WHO SHAPED MICHIGAN

Lewis Cass (1782–1866), second territorial governor of Michigan, did not emerge out of a vacuum. His father, Jonathan Cass, was an officer of the Continental army in the Revolutionary War and part of an elite group that formed the fraternal organization Society of the Cincinnati. The society included well-placed and influential members such as Aaron Burr, Alexander Hamilton, John Paul Jones and George Washington, who went on to hold public office, determine policy and direct the new nation. Membership was inherited by the eldest sons and their descendants, thus making it as aristocratic as a democratic society could dare without a full-fledged monarchy. Like other fraternal societies such as the Freemasons, the Cincinnati provided connections and support to members and their families to help them get ahead. Already usually well educated and having means, young men might get a further boost to acquire military commissions or get appointed to other government posts. This suited the new nation well as it sought to expand borders and consolidate frontier gains and needed patriotic, predictable men to run things. In the Northwest Territory, high-profile members of the society included the likes of General Anthony Wayne, General Henry Dearborn, Oliver Hazard Perry and Michigan territorial governor William Hull.[9]

Unfortunately, William Hull (1753–1825) wasn't up to the confidence placed in him, despite performing well during the Revolutionary War and afterward in many important political roles. When war with Britain was imminent in early 1812, he hesitated to take the offered command of troops in the Northwest Territory to oppose the British in Canada. This reluctance seems to have foreshadowed a career-ending downward spiral for Hull and disastrous outcomes for the United States and its citizens.

First, he went to Ohio to gather militia troops there before marching them to Michigan through the dreaded Black Swamp of the Ohio Territory. During the march, he missed the message when war was formally declared on June 18, 1812. In the confusion that ensued, he was at great disadvantage. After finally reaching Detroit, poor planning and a string of other misfortunes ultimately crippled his resolve. Fear of Indian massacre and lack of military resources led him to make other mistakes and ultimately to surrender Detroit to an inferior force on August 14 without firing a shot. From the outset, he suffered from bad management of the U.S. war effort in the Northwest Territory, incomplete communication, supply problems and other mishaps. When combined with his risk aversion and anxiety about

Ohioan Lewis Cass had the savvy and the connections to tame wild Michigan. But first, he had to get it away from the native tribes. *University of Michigan, Bentley Historical Library.*

Indian atrocities, his judgment went awry. He botched Michigan's military action, dooming the United States to a protracted and bloody conflict with great loss of life and property. He had never been particularly popular with Detroiters for his authoritarian interpretation of gubernatorial power, and there were few tears shed over his removal as territorial governor or his court-martial. He was sentenced to be shot for cowardice and neglect of duty but for a pardon for his Revolutionary War record.[10]

Lewis Cass, who commanded the Ohio infantry under Hull, had chafed under Hull's incompetent leadership and was appointed to replace him as governor in 1813. Cass was no stranger to the Washington power center; although it appears he declined his place in the Society of the Cincinnati when his father died, he was an active Freemason from the age of eighteen, gradually rising to the highest ranks of the Ohio Freemasons before the war.[11] Whether through his father's contacts or his Masonic fraternal network, his long career as Michigan's territorial governor, U.S. senator, U.S. secretary of war, U.S. secretary of state and later U.S. presidential candidate is indicative of his talents, as well as his considerable connections.

After the war, Cass's execution of his role as territorial governor was clearheaded, determined and pragmatic. As an Ohioan, he was familiar with frontier matters such as settler needs and Indian conflict. His attitude and character were appreciated by fellow Detroiters, who saw him as the hero that Hull was not. By all accounts, in these early years he was well suited for the task of territorial governor, ready to charge off from his humble home in Detroit into the frontier of Michigan to explore; ready to face down hostile native chiefs who opposed his treaty pressures; and ready to do whatever needed to be done to tame the wild land, stabilize it and populate it as quickly and efficiently as possible. Once the dust settled, the frontier was going to have to become civilized through agrarian, commercial and industrial mechanisms, and establishing local governmental organization was the key

to making it happen in an orderly way. Statehood and all its benefits was the immediate goal, while positioning Michigan as a more active participant in the federal government had long-term advantages. Cass had powerful friends in Detroit as well as Washington, and he used them to forge the best plan he knew to get Michigan on track for statehood. It was going to take some planning, some investment, some infrastructure, some territorial laws and plenty of determination to make it work.

Chapter 2

DETROIT, CAPITAL OF THE TERRITORY

L ife in and around Detroit had continued unchanged under French, British and then American control. Day-to-day life was instead determined by the fur trade and related commerce. French, Métis (half-French, half-Indian) and members of the Odawa, Ojibwe, Potawatomi and Wyandot (collectively known as Anishnaabeg) tribes came and went as the seasons and trade dictated. Much of the bustle and activity in the outpost involved a transient population, with various Indian dialects, French and English spoken by a multilingual populace.

In 1802, when Detroit became incorporated as a town, it was approximately twenty acres in size, with a resident population in 1805 estimated at five hundred to six hundred people.[12] But Michigan was still just part of an even larger wild frontier stretching beyond and around the Great Lakes. The capital of the Northwest Territory was first at Cincinnati and later at Vincennes. Both were so far away that the conduct of regular business was seriously hampered in Detroit, where it could take days to get back and forth from the capital to execute even the simplest legal transaction. Michigan appealed to Washington and formally became its own separate territory by act of Congress in 1805. William Hull was appointed as territorial governor by President Thomas Jefferson, who also appointed territorial judges to establish and uphold the law. The stockaded outpost town of perhaps one hundred wood dwellings would be the capital

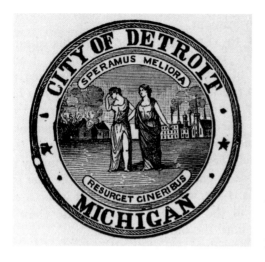

The motto *Speramus meliora resurget cineribus* ("it will rise from the ashes; we hope for better things") was adopted after the fire of 1805 but reflects much of Detroit's long history. *Farmer,* History of Detroit.

of the new territory, with governmental offices handily on site and the fort just outside. Clearly, Detroit was a town with a future. The governor, judges and their respective entourages were expected on July 1, 1805, to officially usher in the new territorial government. The enthusiasm for growth and expansion was captured in the territorial motto of Michigan: *Tandem fit surculus arbor* ("a twig in time becomes a tree").[13]

Detroit had much to look forward to as it prepared for the eventful day. The influx of governmental activity would be a great boon to commerce, creating economic opportunities that would transform the town. But two weeks before their arrival, the town was transformed by a completely unexpected turn of events. A raging fire sparked by wind-blown embers engulfed the town. Closely set French-style wood and log buildings were burned to cinders in a mere two hours. The entire population was made homeless and vulnerable, as even the stockade walls burned to the ground. No one was killed, but property losses were complete. From the simplest tradesman to the well-stocked merchant, all were now destitute and forced to take refuge with local farmers, at the nearby fort or in the open, getting food and shelter as they could. Residents quickly began making plans to rebuild and get back to business. The city's new motto captured the hopes of Detroit's suffering residents: *Speramus meliora, resurget cineribus* ("we hope for better things; it will arise from the ashes").[14] Sadly, it would not be the last time this sentiment could be applied to Detroit's misfortunes.

PLANNING THE NEW DETROIT

When Hull and the judges arrived at the charred remains of their capital, plans for rebuilding Detroit could finally begin in earnest. They began organizing the effort almost immediately and appealed to Washington for help. Congress agreed (some said because they were encouraged with an abundance of spirits) to give a free lot in the new city for everyone over the age of seventeen who had resided there before the fire. A special land board was to distribute the lots. Jurisdiction resided with the trio of territorial judges, two of whom were Frederick Bates and John Griffin. The third and chief justice was a Washington, D.C. lawyer whose reputation was that of an odd, eccentric, but brilliant legal mind. This man was Augustus B. Woodward.

Woodward's mark on Detroit is physically recognizable today in its layout. It was inspired both by the radial plan of his hometown of Washington (which was based on Paris, France) and his astronomical interest and observations of star movements. The design had a series of interlocking hexagons that created angular lots of various sizes. These were intersected by wide streets that radiated outward from the riverfront and theoretically into the far distance. However, the beauty and elegance of such a grand (some thought grandiose) plan was lost on many Detroiters. It was altogether foreign and counterintuitive for a frontier populace accustomed to narrow streets, small buildings and the enclosure of a stockade. But the citizens had little say in the matter, and surveying began.

The center of the design was dominated by a wide street that led northwest away from the river and into the forest, along the existing footpath of the Saginaw Trail. This major street, dubbed Woodward by the man himself, bisected the new city plan and was the center of activity. Its planned width—120 feet—befuddled many, who saw it as a waste of perfectly good property lots. Similarly wide streets followed the routes of the other Indian trails that led northeast, along the river and to the west and southwest, like the spokes of a wheel. But the most controversial street was the one that the judge named for himself. Woodward Avenue's predominance foreshadowed its importance to come, and its outer reaches into the forest would lead to a great future for Michigan.

Inspired by Paris, Judge Woodward designed a plan to rebuild Detroit that radiated outward, like the spokes of a wheel. The Saginaw Indian trail that ran northwest was named Woodward Avenue. *Detroit Historical Society.*

DETROIT AND THE WAR

In the ensuing years, Detroiters rebuilt, mostly along Judge Woodward's plan, and efforts were made to bring order to the town through an exhaustive review of the land allotments and reapportionment of property. Governor Hull continued to assert American interests. In 1807, he negotiated the Treaty of Detroit, in which area tribes lost a huge tract of land—nearly a third of southern Michigan. But it wasn't only the United States that had interests in the territory. Other eyes were on Michigan. The British and their native tribal allies (mostly Chippewa or Ojibwe) were strengthening their positions in Canada and along U.S. territorial borders during this period. Security and stability were far from assured.

When the War of 1812 finally erupted, soon to be followed by Hull's surrender, the British duly occupied the city. Detroiters who were unable or unwilling to leave were faced with loss of property, inadequate protection from Indian assault and lack of food, fuel and clothing. Conditions were scarcely improved when American forces took the city back. Deplorable hygiene and lack of drainage near the fort resulted in an epidemic of deadly disease that brought more death and devastation. Somehow, the remaining Detroiters managed to survive until the war ended in late 1814, but the population was greatly diminished.

POSTWAR MIGRATION

Detroit needed to rebuild its economy, its population and the city itself. In Woodward's ambitious vision, all roads led from Detroit as the center of the territorial universe. But now those roads had to lead a population back to it. In fact, roads had little to do with the flow of postwar migrants to Michigan. Waterways were the only real highways for travelers bound for Detroit. The people who began to trickle into the city came from New York, Pennsylvania and parts east. The vast majority had suffered economic losses due to the war. Migrants sold all they had, packed what was left into a few trunks and made their way west. They had little left to lose.

While some hardy people came to Detroit by foot, walking for weeks across tracts of land in Canada north of Lake Erie, this was a dangerous route. Belligerent Indians, highwaymen and cheats preyed upon travelers who had

to carry whatever money they had, usually silver coin, on their person. The cost of inns was usually more than could be afforded, so sleeping in the open air, even in cold rain and freezing temperatures, was not unknown.[15]

If money could be spared, migrants could make their way to Buffalo on eastern Lake Erie. From there, passage could be bought on one of the few sailing vessels on the lakes, yet this choice was risky. Fickle winds could create long delays, and many a ship had been sent to the bottom or broken to bits on sandy shoals by sudden storms. Then, after 1818, there was a new option: the trip to Detroit could be reduced to as few as three days with passage on the first Great Lakes steamship, the *Walk-in-the-Water*. This was not without its own hazards. Sudden squalls could blow up in Lake Erie, creating dangerous wave patterns. Even under steam power, the trip to Detroit could take as long as two weeks under unfavorable conditions. Cramped quarters resulted from there being more migrants than comfortable passage could accommodate. But the pressure of people wanting to migrate was unrelenting; the completion of the Erie Canal in 1825 created an inexpensive and direct water route through New York. Eventually, more steamers were built to handle the ever-building numbers of travelers who were Detroit-bound.

A NEW LIFE FOR OLD

When they finally started up the river toward Detroit, early travelers got their first glimpse of the Michigan Territory. What they saw along the river were one-and-a-half-story wood structures with dormer windows above low overhanging eaves facing the water. These traditional French dwellings were less and less occupied by French-speaking *habitants* (descendants of French settlers). Although they had had a rich history in Michigan for a century and a half, after the war, the French were increasingly marginalized. The Americans at Detroit misunderstood their culture and way of life, and a gulf formed between the old culture and the new. Eventually, the *habitants* drifted away to Canada, leaving behind their traditions, their ribbon farms, their French place-names and their legendary pear trees along the river for incoming Americans to wonder at.

As they neared the city, visitors saw high sandy dunes and marshy streams along the waterfront, which teemed with whitefish and waterfowl. The water was so clean that people often dipped their cups into the river to drink.

Native American canoes were commonplace and sometimes greeted the steamer when it came upriver. An observant traveler might notice rounded mounds of earth at the water's edge, left behind by ancient native people. As the town finally came into view, small docks with boats and ships became numerous. Wooden footbridges carried traffic over small rivers and streams, with all paths heading toward town. The military fort could be seen with its wooden palisade, while houses and commercial buildings lined up along dirt roadways full of pony carts and stacked with goods. Sewage and other runoff drained into the river. Church spires could be seen, and bells and voices in various languages could be heard before the steamer's whistle finally announced the ship's arrival.[16]

At the center of town, a wide dirt avenue led directly to the river, where wharves and port activity took place. This was Woodward Avenue, and once on the street, visitors could look northwest up its straight path to see the Detroit market a few blocks away. Many hotels and inns had been built to accommodate travelers and line the pockets of their owners, as the migrant

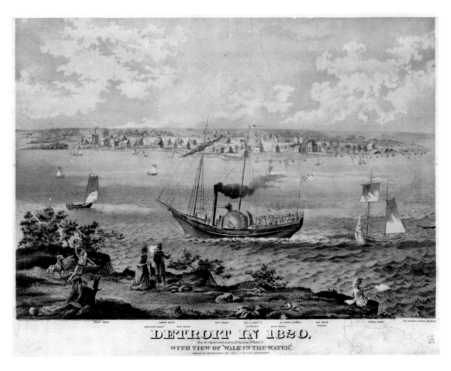

Michigan's territorial capital of Detroit was a growing commercial center on the Great Lakes that was the destination of migrant settlers looking for a new life. *New York Public Library.*

business was a lucrative one. An example was Benjamin Woodworth's famous Steamboat Hotel. He enlarged his residence as a hotel to cater to the wave of migrants. But more than that, it became the unofficial center of commerce, where lake captains came to share news and make business arrangements. The enterprising Woodworth soon capitalized on his hotel's popularity by forming the first stagecoach service in Michigan Territory.

Although Woodworth was operating on a large scale, his example was not lost on others who sought to benefit from the steady stream of travelers coming to Michigan. A good portion of the business-minded populace was ex-military—army regulars or militia who stayed when the war ended. Others were former officers, with more means and greater intentions of profiting at a larger scale from Michigan's veteran bounty lands. Many either knew each other from the war or came to know each other in the relatively small Detroit society. They made business investments, married the sisters and daughters of other prominent men and generally went about the serious business of investing in a profitable new post-military life. This new life was an all-American one. The British, the French and the native peoples had no place in it.

The promise of postwar Michigan Territory, however, was not lost on other sociocultural groups, who were not necessarily excluded but neither was their way made easy. They needed to work harder, longer and be more determined to be accepted and successful at making a new life. They included foreign immigrants and those seeking to establish religious communities, such as Quakers and, later, Mormons. And there was a steady stream of newly freed and fugitive slaves, aided by abolitionists to get to Detroit on the way to final safety in Canada. Frustrated and determined slave owners traveled from the South looking for runaway slaves, posting rewards and seeking legal redress. Michigan had played an important role in opening the way for fugitives since 1807, when slavery was declared illegal in the territory. That landmark decision was made by none other than Judge Augustus Woodward.

WOODWARD: THE MAN AND THE ROAD

Augustus Woodward (1774–1827) was a unique character who made his personal mark widely felt on early Michigan. He had many enemies as

well as admirers. When first coming to the territory, he and Governor Hull were reviled by many of Detroit's citizens for taking away their voice in civic affairs when the new territory was formed in 1805.[17] He was brilliant but odd and had what many considered repugnant personal habits, often remaining unbathed, sleeping in his office or wearing soiled clothing for days on end. He was keenly interested in the sciences, especially astronomy, which was incorporated into his plan for Detroit. He also helped found an educational institution in the town of Detroit that eventually became the University of Michigan. What is euphemistically termed "eccentric" was possibly a form of mood or bipolar disorder, which fueled his ideas with intensity and creativity but created erratic behavior and interpersonal difficulties. He could be capricious in his application of the law. He was stubborn and often didn't get along well with the other territorial judges. Many were opposed to his plan for Detroit as a personal vision that was indifferent to the needs of the populace. Yet when the other judges left during the war, Woodward stayed on to help the starving Detroiters. He traveled to Washington on their behalf to appeal for aid, which he obtained. And among his most important accomplishments, Woodward was responsible for the ruling that made slavery illegal in Michigan. This legal doorway was the opening many in bondage needed to make Michigan their destination. And perhaps in his visions he saw that his namesake street that became a forest trail to Saginaw would become famous the world over as the one and only Woodward Avenue.

SOLOMON SIBLEY, DETROITER WHO SHAPED PONTIAC AND EARLY MICHIGAN

Solomon Sibley (1769–1846) made investments in people, property and ideas and was instrumental in the success of early Detroit, Pontiac and Michigan as a whole. He realized the importance of the Saginaw Trail to achieve the government's objectives in settling Michigan Territory and working toward statehood. Sibley had been a fixture in Detroit since 1797, when he migrated shortly after the British finally vacated after the Revolutionary War. At the time, he was one of only two lawyers in the settlement, where they were sorely needed, regularly traveling by horseback to court in Ohio to conduct business. When local citizens incorporated as a town in 1802,

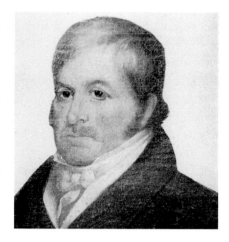

he was instrumental in drawing up the charter. When the new territorial government took power away from the town's trustees, Sibley and others took the matter to Congress. He was later elected the first mayor under the first city charter of Detroit in 1806. When the War of 1812 broke out, Colonel Sibley was among a handful of men who took steps to muster a militia to defend the town without waiting for Governor Hull's approval.[18] Sibley then helped lead the defense of the city until Hull surrendered just two months later. Not surprisingly, he had dealings with all the major movers and shakers in Detroit, both before and after the

As chairman of the Pontiac Company, prominent Detroit lawyer Solomon Sibley and his wife, Sarah, were instrumental in the success of the new town. *Detroit Historical Society.*

war. Later, Sibley's government career included stints as U.S. attorney and later Michigan Supreme Court justice.

His influence in Detroit and the Michigan Territory was broad, and he was connected through business and family to major commercial and governmental networks. His wife, Sarah Sproat Sibley, was daughter to an original member of the Society of the Cincinnati; his daughter married the famous Detroiter and later mayor Charles Trowbridge; and his son Henry was a partner in John Jacob Astor's American Fur Company, as well as later governor of Minnesota.[19] In addition to his involvement in the Pontiac Company, Sibley and his wife made other investments in the wilderness town to help ensure its success.[20]

Solomon Sibley has been described as an important ally of Lewis Cass, with whom he had been acquainted since his early travels to Ohio. In addition to their shared interests in Detroit and Pontiac, they were sent to Chicago as part of a governmental commission in 1821 to negotiate a treaty for the remaining Indian lands in southwest Michigan. The tribes were no match for the pair, and Michigan's public lands were duly increased.[21] Sibley could also have impact on a much smaller scale. He was instrumental in the life of Elizabeth (Lisette) Denison Forth, a former slave who worked for him and who, with his guidance, became part of the Saginaw Trail and its story.

ELIZABETH (LISETTE) DENISON FORTH
(1790–1866)

She was born a slave in the Michigan Territory in 1790 to British landowner William Tucker, who had purchased a large tract of land from the Indians in what is now Mount Clemens. He bought Lisette's parents from William Macomb (brother of Alexander Macomb) of Grosse Ile to work his land. When he died, his will liberated the parents but not the Denison children. They were willed to his family, who refused to free them. When Michigan became a territory in 1805, the Denison siblings were represented by Detroit lawyer Elijah Brush in the first U.S. case of slaves suing for freedom. Judge Woodward heard the case but found in favor of the Tuckers due to a technicality in the property laws applying to British citizens under the Jay Treaty following the Revolutionary War. Lisette and her family escaped across the river to Canada; shortly afterward, further case findings from Woodward finally established slavery as illegal in Michigan Territory, effectively giving Lisette her freedom.[22]

After the War of 1812, Forth began to work for Solomon and Sarah Sibley in Detroit. Despite her inability to read and write, she demonstrated capable business sense; she accumulated savings, bought and sold property and made additional investments—all quite remarkable for a time when women had limited legal rights. She also loaned funds to Sibley at one point. In 1822, she arranged through Sibley to purchase forty-eight acres of land in the new settlement of Pontiac, finalized in 1825. This made her the first African American, and one of the first women, to own land in Oakland County.[23] In 1827, at around forty years of age, she married Scipio Forth. He died by 1830, and she remained unmarried. Shortly after her marriage, she gave her brother a lifetime lease to farm the Pontiac property for a nominal fee. However, her brother's wife and two of their children died soon after that. Even with Lisette's support, he went into debt. He was in such reduced means by 1834 that he left Pontiac, indenturing his son for ten years in the process. Forth continued to lease the Pontiac land for rental income but sold it by 1837, investing in a house in Detroit for income and a place to live in later life. She purchased stock in the Great Lakes steamer *Walk-in-the-Water* and also in the Farmers and Mechanics Bank. By holding on to her bank stock during the banking crisis known as the Panic of 1837, she was able to realize a profit afterward. After 1831, she worked for prominent Detroiters John and Eliza Biddle for many years, accompanying them to France for an extended period and learning to adapt to Parisian life. Despite her early life, Forth was less concerned with racial inequality than she was with poverty

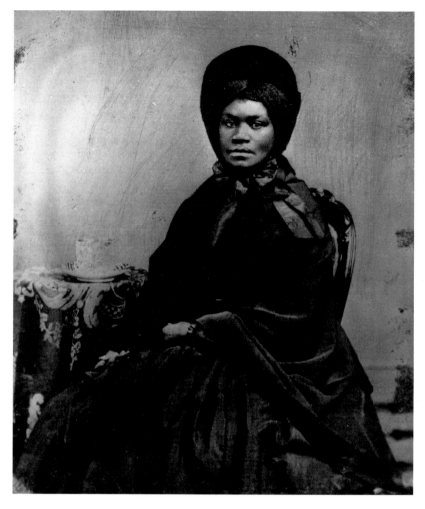

Elizabeth (Lisette) Denison Forth overcame slavery and illiteracy to invest in early Pontiac and the Michigan Territory. *St. James Episcopal Church, Grosse Ile, Michigan.*

and seeing to the spiritual needs of the unprivileged. At her death, she left a large part of her sizable estate to build St. James Episcopal Chapel on Grosse Ile, which is still in existence.

Forth's ability to navigate the white world of territorial and early statehood Michigan was remarkable. Her contribution to early Pontiac is part of the story of the Saginaw Trail and demonstrates how determination and talent enabled her to overcome the obstacles of birth, sex and race to shape a better life for herself as well as others.

Chapter 3
PONTIAC, FIRST TOWN IN THE WILDERNESS

The people who set about transforming the frontier into a secure and productive part of the new nation were essentially of two kinds: enterprising investors with business acumen to overcome barriers to settlement for a profit; and the common settler, the instrument of their vision. For the determined man with the confidence to take the risk and the drive to succeed, it was a wide-open world of opportunity. Those in more desperate circumstances—the uneducated and underprivileged; women; African and Native Americans; and foreign immigrants—would need to be even more resourceful to make a go of it. But despite legal and cultural barriers, there was room for them to participate as well.

SURVEYING THE MICHIGAN TERRITORY FOR SETTLEMENT

In the years after the war, surveyors fanned out all over the expanse of the Northwest Territory to explore, record and demarcate the lands. Two million acres of the 1807 treaty lands were set aside in Michigan as military bounty lands. They were available at a discount, both in recognition for service as and an inducement to settle. In 1815, the first surveyors set out but were grossly unprepared, or lacked enthusiasm, or both. After halfhearted

efforts to navigate swamps and floodplains in an especially wet season, they failed to complete their survey contracts amid a flurry of complaints of lakes, muck and a continuous, miserable landscape. Surveyor General Edward Tiffin reviewed their appraisal of Michigan's interior. The soil was sandy. The soil was poor. The swamps were endless. The land was useless for agriculture. The veteran bounty lands of Michigan were not worth the trouble, it seemed, as he relayed to Washington:

> *I think it my duty to give you this information, believing that it is the wish of the government that the soldiers should have (as the act of Congress expresses) lands fit for cultivation, and that the whole of the two millions*

White oak swamps were wet and mucky much of the year and created travel hazards on the Saginaw Trail. *Library of Congress.*

*of acres appropriated in the territory of Michigan will not contain
anything like one hundredth part of that quantity, or is worth the expense
of surveying it....*

*The country...is, with some few exceptions, low, wet land, with a very
thick growth of underbrush, intermixed with very bad marshes....The
number and extent of the swamps increases....*

*Many of these lakes have extensive marshes adjoining their margins....
Swamps...are interspersed throughout the whole country and filled with
water....*

*In many places, that part which may be called dry land is composed
of little, short sand-hills forming a kind of deep basin, the bottoms of
many of which are composed of marsh similar to the above described. The
streams are generally narrow, and very deep compared with their width, the
shores and bottoms of which are...swampy beyond description; and it is
with the utmost difficulty that a place can be found over which horses can
be conveyed in safety.*

*....Taking the country altogether, so far as it has been explored, and to
all appearances...it is so bad that there would not be more than one acre
out of a hundred, if there would be one out of a thousand, that would in
any case admit of cultivation.*[24]

When Congress received the bad news, military bounty acreage was
quickly made available in Illinois and Missouri territories instead.[25]
Hundreds, then thousands of settlers came through Detroit on their way
west, bypassing the morasses of Michigan for more promising country.
Even so, the surveys in Michigan were to be completed anyway. Another
wave of crews set out to finish the unhappy task of running township and
section lines across miles of marshes and swampy forest terrain.

CHECKING IT OUT

Meanwhile, back in Detroit, territorial governor and Indian agent Lewis
Cass was taking a keen interest in his surroundings. He was a good observer
who spoke the various dialects of Indians who came and went from his
office. Despite the early surveyor reports, fur traders, recent survey crews,
local adventurers and the native people said something different about the

interior of Michigan. Yes, there were swamps, and they must be crossed and navigated. But there were also trails that were known by the well-traveled native and Métis traders who used interior land routes. Indian trail marker trees showed the way, and not so very far north, swamps gave way to good land. The Chippewa and their Anishnaabe brethren, the Potawatomi and Odawa, had been planting summer gardens for generations. Beans, maize, squash and pumpkins were grown and harvested as a significant part of their diet. The native peoples gardened in small prairie areas and sections of land known as "oak openings."[26] These areas were maintained yearly by the Indians with annual burning to enrich the soil and prepare them for the next year's plantings. They needed very little clearing and would make excellent farms.

Other stories circulated of good lands in the interior. Young Benjamin Graham was part of a survey crew in early 1816 and had liked what he had seen up the Huron River of the St. Clair (Clinton River). In the winter of 1817, the extended family led by Alexander Graham moved all their worldly goods to a forest site Benjamin had scouted, making them the first homesteaders in the interior. But as the land had not yet come to public sale, they were squatters, gambling that they would get rights to purchase the property when it went to market.[27] They settled on a location where the Paint and Stony Creeks joined (later the village of Rochester). They cleared the land, planted crops and orchards, built a mill and were becoming quickly established. They seemed to be thriving.[28]

Lewis Cass was determined to get to the bottom of the matter and stop the loss of prospective migrants to Michigan Territory. He and a party of Detroiters explored the wilderness along the Saginaw Trail in late October 1818. Several members of the expedition published their official findings in the *Detroit Gazette* on November 13, 1818, in an open letter that portrayed the party in near-heroic terms. It touted the many natural features and sites for productive farms in various locations in the surveyed wilderness.[29] But word was out even before the *Gazette* report. Little escaped notice in Detroit, and speculation about land was a hot topic. Everyone knew there had actually been two attempts to explore the trail, as noted by Judge Woodward in an address to the Detroit Lyceum (an educational discussion and debate society). Called "Narrative of a Recent Exploring Party in the Territory of Michigan," it satirized the self-centered exploits and questionable motives of the party. It also implied (as did an account by Reverend John Monteith), that the first attempt was hardly heroic. A brash and ill-advised affair, it ended with the men losing the trail in the forest, becoming separated and being

forced to follow streams in the dark to find their way back to the Detroit River and into town the next day.[30]

About a week later, they were better prepared with men and supplies, and this time they included the knowledgeable Monteith and an Indian and a French guide. The second foray lasted eight days, following the trail and exploring for several miles along side trails before returning to Detroit. This was the journey triumphantly reported in the *Gazette*, redeeming both men and landscape. The story found its way into the newspapers back east and fanned much excitement in Detroit as well.[31]

THE CASS EXPEDITION STORY

Whether Cass actually was part of the Saginaw Trail expedition has been disputed, although the evidence suggests he was there. First, it was in his official interest and consistent with his in-command character to participate in such an enterprise; he was a man of action who would itch to explore the interior, as shown by his 1820 expedition throughout northern Michigan. Secondly, the *Gazette* account declares that the trail explorers named lakes for themselves; Cass and Elizabeth (for his wife) Lakes were named on that trip. Third, Judge Woodward's public satire of the expedition, delivered soon after, lampooned Cass as one of the group. In any event, the story of Cass's encounter with the trail has entered the realm of legend and become fused with its actual history. The story is a metaphor for seeking, and finding, the American dream. This gives it an enduring sense of truth, and as with all legends, it has a basis in fact.

Accounts state that the party left Detroit on horseback, following Woodward Avenue until it turned into the trail and led into the forested swamp. The Indians and French often used sturdy and tough little French ponies for transport, but the Saginaw Trail was actually best navigated on foot, single file, most of the year. In the woods, centuries of growth in the tamarack, northern hardwood and other heavily forested wetlands left gigantic deadfall trees lying in all directions, often blocking the way. Scrambling up and over trunks and root humps in the low light of the forest was hard enough for nimble-footed men, so whenever possible, ponies were left behind and travelers carried only what was essential. For the horses of the Cass party, sure footing would be difficult until they got to high ground.

After struggling to find and stay on the trail, the expedition would have emerged on dry land later on the first day. Legend describes Cass remarking that a very large oak tree he rested under at this point was "indeed a royal oak," said to be the origin of the city by that name. At the end of the second day, the group finally reached a crossing of the Saginaw Trail and an east–west path that led along the (Clinton) river to the Graham settlement. It was the well-chosen site of a summer camp of the Saginaw Chippewa and had much to recommend it for settlement. Over the next several days, they also explored around the many lakes and streams of the upper river area, locating surveyor marks and making notations of the landscape's features. As they later reported, the party delighted in naming these lakes after themselves (which equally delighted Woodward in his "Narrative").[32] Their last day took them east along the river, staying the final night with the Grahams before returning to Detroit.

The purpose of their trip is clear in light of who these men were and what happened next. As investors and ex-military, they were looking for an opportunity to turn veteran bounty lands to profit, simultaneously boosting migration to Michigan. With Cass's blessing, they could establish a planned town, with outlying farms supporting and ensuring the town's success. The Indian camp at the river crossing had exactly what they were looking for, and before they returned, they had formulated a plan, which they executed immediately before someone else could.

It's Who You Know

A list of the exploring party can be deduced from the lakes named for them, including Wing, Sibley, Stead, McKinstry, Whitney, Macomb, Canfield, McDougall, Monteith and Cass. On November 5, 1818, within days after returning, the first six formed a partnership, called the Pontiac Company, with ten other investors: Stephen Mack, William Woodbridge, John L. Whiting, Henry I. Hunt, Abra(ha)m Edwards, Archibald Darrow, Andrew G. Whitney, William Thompson, Daniel Leroy and James Fulton. Solomon Sibley was designated chair and Stephen Mack agent. The purpose was to purchase a large tract of land and plat a new town in the wilderness. The company had a sound business plan with everything going for it: advance knowledge of the perfect site and the area around it; the backing of influential men in Detroit; the support of the governor; access to the military discount (Macomb, Sibley

and Mack had all been officers); and a sense of the competition from the Graham settlement. The day after the company formed, Mack bought 1,280 acres on the Saginaw Trail that encompassed the Saginaw Chippewa camp.

Ironically, the town would be named Pontiac, a tribute to the renowned war chief of the 1760s who, like his native people, was no longer a threat. The company lost no time getting settlers on site. Workers were sent in early December to begin a dam, and a sawmill soon followed, along with a log cabin at the trail crossing. Stephen Mack and three other families moved into the cabin to permanently occupy the site. Mack, no stranger to commerce or large building projects, formed a secondary partnership with Shubael Conant and Solomon Sibley to further public improvements for the town. Thus, the company demonstrated the viability of the settlement, which was essential for a healthy return on their investment and also for certain executive action due out of Cass's office very soon.

SECOND ONLY TO DETROIT

Just a few weeks later, on January 12, 1819, Governor Cass set the boundaries for a new Michigan county, to be called Oakland, initiating formal governmental organization and its benefits. A commission was appointed to establish a county seat. The Pontiac Company applied for the designation four weeks later. It would mean securing the town's future through schools, public buildings and other improvements that would bring more settlers, draw additional investment and stabilize its economy. The only other candidate was the Graham settlement to the east. It had shown marked success in just two years, and the site had good mill sites, established crops and a beneficial location down the Clinton River on an east–west Indian trail. But its residents were squatters who had not purchased their land.

Had the Pontiac Company been slow to build, or had it not had financial backing in Detroit or with the governor, or had it not shown it had a viable plan conceived by seasoned investors who actually owned and controlled a large tract of land, or—possibly the winning point—had it not offered to set aside lots for a county courthouse and schools, things might have gone otherwise. But Cass decided in favor of Pontiac in 1820, paving the way for the town to be a new center of power in the Michigan Territory, second only to Detroit.

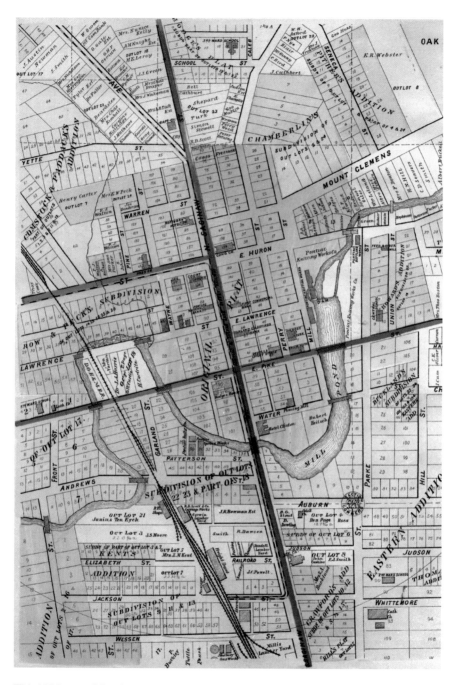

This 1896 map of Pontiac shows the original 1819 location where the Saginaw Trail (Saginaw Street) crossed the Clinton River at the traditional campsite of the Saginaw Chippewa. *Library of Congress.*

STEPHEN MACK AND SONS

Stephen Mack (1762–1825) epitomized the determined New Englander who found a future in Michigan, bringing with him the personal drive and values that helped shape the territory for those who came after. He and his family played a central role in early Michigan and were also connected to some who would become even more famous and influential in our growing nation.

Mack had always been a man of action, a Vermonter who joined the army at age fourteen and rose to the rank of colonel in the Revolutionary War. Afterward, he pursued business interests back home, married a minister's daughter and had twelve children. Many would have been content with such a life. But Stephen had a knack for sensing opportunity and was unafraid of risk and hard work, so he came to Michigan Territory around 1807 to expand his mercantile interests. He was already in his forties but had the energy of a much younger man and quickly built partnerships and his business. He served Detroit as village supervisor and trustee and was a legislative council member from early on.[33] His family remained behind in Vermont with his wife, Temperance; several older children were already married, but their youngest twins were just two years old. A new territorial town may be great for business but was not the place for children.

Before long, his business grew to require a large warehouse and two ships. At the outset of the War of 1812, he joined the militia as an artillery captain, but when Hull surrendered, he was sent to Quebec with other officers. During the British occupation, his Detroit warehouse was looted and burned and his ships confiscated. Afterward, he was unable to get compensation from the United States forcing him to start over.[34] He took contracts in road construction, milling and any likely opportunity in postwar Detroit. He formed and dissolved partnerships with most every prominent figure in town. By 1817, he and colleagues—more than half of whom soon became members of the Pontiac Company as well—had founded the first bank in the territory, the Bank of Michigan.

Stephen Mack worked diligently to make the town of Pontiac a success, even relocating there and leaving his Detroit business in the hands of his son Stephen. Before long, Stephen Jr. was off to Illinois Territory in the employ of John Jacob Astor's American Fur Company, where he was a successful trader and founded his own community. Mack's son John stepped in and became an important businessman and politician in his own right; Mack Avenue in Detroit is named for him. And his youngest son, Almon, was

instrumental in building the Mack business interests, ultimately settling and building the town of Rochester.

Despite his youthful vigor, Mack suddenly took ill of a stomach ailment and died in 1826. This event had important consequences for the women of the Mack family, as Stephen was bondsman for the cashier of the Bank of Michigan, who embezzled more than $10,000, leaving Mack responsible for the debt. At his death, there was little left for Temperance and his dependent children.[35]

A WOMAN'S PLACE

The women of the Mack family illustrate how nineteenth-century gender roles and cultural pressure could affect an entire family through its women. For another century or more, women would not be legal equals of men. They were unable to vote or have voice in civic matters and were considered incapable of understanding politics anyway. It was difficult to own property, even when inherited. The prevailing law transferred all of a woman's assets to her husband upon marriage, and that included earnings, if she had them. For men, the conventional purpose of marriage was in procreating and having a wife to keep house and raise his children. This was for many a practical arrangement, and in turn, a man's responsibility was to build a life foundation—a farm or business—to see to the family needs.

Sons were desirable to carry on family business or farming. Daughters were groomed to "marry well"—that is, to a man who would help support the family business or reinforce important social networks. What made young women appealing were the skills and talents that would make them good housekeepers and child rearers. Often, if lucky enough to have formal education, women were trained to be good companions and taught desirable skills such as playing piano or reciting poetry. To entice a marriage proposal, a dowry of cash or property was customary, reinforcing the businesslike aspects of the arrangement. Love, if it existed, was a nicety but not expected.

Women's domain was the home; this included preparing meals and making sure food supplies lasted through lean times, clothing the family and making their shelter comfortable. Women also were caregivers and healers of the sick and dying. When a spouse died, there were good reasons for remarrying quickly. A man with young children needed a woman to take

care of them and keep house. A woman might suffer socially or financially if she remained a widow too long. If she had young children and unstable economic or living circumstances, she needed a husband to help ensure the well-being of her children. It was not uncommon for a brother to marry his deceased brother's wife as a way to care for his blood relatives, and the reverse could happen with sisters. The drive to protect the family was very powerful. In rural America, it was also common for two brothers to marry two sisters, reinforcing (and complicating) family bonds. Single women were outside the norm; they might live with an adult sibling to help with housekeeping or care for aging parents. Rarely, they became schoolmarms or worked as domestics to get by. Single men, by contrast, had the freedom to travel, hire out their services, become apprentices in a trade, enter into business contracts and explore new opportunities.

In the frontier, women of necessity gained a measure of independence simply because survival might depend on it. Everyone in a pioneer farmstead worked and contributed to the entire family benefit, so men's and women's roles could be more fluid. However, with prosperity came the reinforcement of conventional social norms that emphasized traditional roles. In general, for a woman to have a voice and direct her own affairs was a rarity. But a woman could gain some measure of control by having influence with her father, husband or sons.

Childbirth could be a woman's doom, but if she survived that, raising a healthy child to adulthood was the next major challenge. Education and religious instruction were considered part of her child-rearing responsibility. Sons who were successful and daughters who were sought by eligible suitors reflected well on their mother's proper upbringing. To satisfy social needs, women depended on female relatives or congregated with neighbors, often going beyond their daily workload to help another in need. Despite the hardships, frontier women often survived years beyond their spouses.

Being so much in the background, women are barely mentioned in historic accounts. Since they were largely unable to buy and sell property, hold public office or form business ventures, their activities are not often recorded. Marriages, children's births and baptisms and deaths are sometimes the only details that survive of a woman's entire life. If a record exists, it may not even include the woman's given name—she might be identified only as "Mrs. [husband's name]." In the case of the many women in the Mack family, more substantial information survives that permits a glimpse of how an entire family of women responded to important historic events of the era.

THE MACK WOMEN

Temperance Bond Mack (1771–1850) fulfilled the traditional expectations of women for the first fifty years of her life. She followed Stephen to Detroit in 1822 with unmarried daughters Lovina and Fanny and teenage daughters Almira and Achsa in tow. Lovina, unmarried at twenty-seven, went to Pontiac to keep house for her father. Within a year, however, Lovina was the first white woman to die there. Sons Almon and John were busy with their own lives, leaving Temperance and the others to move to the Pontiac wilderness to set up housekeeping. It was far removed from the world they knew back east, or even at Detroit, lacking many basic comforts and being physically demanding as well. By 1826, Stephen, too, had died, leaving some property but very little income for Temperance to live on. Married daughter Mary Mack Dort joined her in Pontiac, as did daughter Harriet Mack Hatch, who briefly became a widow in 1825 before marrying Judge Gideon Whittemore, remaining in Pontiac. Married daughters Ruth and Rhoda also relocated to Michigan from Vermont, bringing all the mothers and sisters together. By 1830, however, the winds of change were blowing through the Mack family, creating a growing divide between them and accentuating the cultural pressures faced by women of the time.

LUCY MACK SMITH, THE BURNED-OVER DISTRICT AND THE MORMON PROPHET JOSEPH SMITH

As it happened, the women of the Mack family found themselves in the path of a religious movement that first seized immigrants in the East before barreling its way through Michigan, Illinois, Missouri and on to Utah. Mormonism arose as part of the Second Great Awakening, a religious fervor beginning in the late 1820s that swept like a wildfire from New England across New York, earning Western New York the nickname "Burned Over District."[36] Characterized by the phenomenon of "revivalist" meetings in outdoor camps that drew hundreds of people, adherents often manifested intense spiritual experience in trances, ecstatic spells, visions and the like. Lucy Mack Smith (1775–1856), Stephen's sister, became an integral part of a new church that grew out of the

movement: she was the mother of the Mormon founder and prophet Joseph Smith. Through her son, she gained a central role in the early church and had a major impact on the Mack family.

After Stephen's death, Lucy visited Michigan to bring family members into the new faith. Both Temperance and Almira became among the first members of the new Mormon church. Almira's second husband, Benjamin Covey, became a bishop, married four more wives and became important in the church hierarchy, with Almira rising alongside.[37] Mary and husband David Dort also became Mormons at an early date. When Mary died in 1827, David (who also became a bishop) married her sister Fanny Mack, still unmarried at age thirty-nine. Fanny cared for their five children and had five more of her own before she died ten years later. All followed Lucy west with the church and never looked back. With the death of her husband and son Joseph, Lucy became alienated from his successor, Brigham Young, and her influence diminished. The remainder of the Mack women resisted Temperance's entreaties to become Mormons and move west. Harriet remained in Pontiac and stayed in contact with the Mormon Macks but eventually relocated with her husband, Gideon Whittemore, to northern Michigan to start a lumbering business.

The life of Temperance Bond Mack illustrates both a traditional woman's role in early life and her choice to follow an unconventional, self-directed path in later years. When Stephen died, she was left without means, yet she determined to start a new life at age sixty with religious faith alone and without being defined by either husband or son. She, like other migrants on the Saginaw Trail, wanted a better life for herself and was willing to struggle to get it, no matter where the path led.

Chapter 4
THE HALFWAY POINT

The Pontiac Company was not alone in looking to benefit from the public sale of ceded Indian lands. After the War of 1812, former soldiers began to congregate in Detroit. Some had families back home; others were unattached. They included ex-military from the east, army regulars and former officers whose characters were varied; some were heroes, some simple opportunists and some outright criminals. They picked up work and gossip and bided their time; the territory was poised to offer opportunities in an era of economic transition that included both the old fur trade commerce and the new postwar U.S. expansion. Despite its bad reputation, many of them had keen interest in the possibilities of the veteran bounty lands of Michigan. They might be after land for a family homestead or eyeing profit in large-scale land speculation by buying low and selling high. Because cheap wilderness land increased in value markedly once improved, an investor sometimes purchased promising land and sought tenant farmers who would work it for a year or two while saving to buy their own property, selling the improved land for a handsome profit.[38]

Land hunters often used local guides to scout for prospective land, a process that could take months. The most desirable lands had farming potential, especially with oak openings or prairie that was relatively easy to clear. Access to good streams for mills, springs for fresh water, natural stone or stands of pines for building or clay deposits for making brick were a plus. First steps were to occupy the land as quickly as possible. Forest trees were girdled to kill them so small crops could grow in the

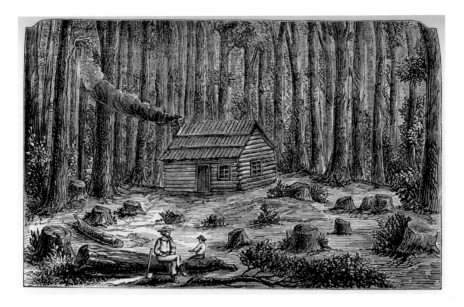

The first logs cleared in the Michigan forest were used to build a cabin shelter. *Nowlin,* Bark Covered House.

resulting light next season. Others were cut at the stump to build a cabin, often intended for occupation for only a few years. Gradually, stumps were removed with the help of oxen, and large bonfires would burn for days to reduce all the unwanted timber and brush. Families with more than one able-bodied adult could accomplish quite a lot within the first year and within two or three could be selling surplus crops and becoming more financially comfortable.

Although public lands in southern Michigan territory were first sold at the Detroit land office on July 6, 1818, the majority of early sales were in the immediate vicinity of the city where the landscape was well known. Parcels in the interior remained unclaimed. The earliest Tiffin survey reports of 1816 were discouraging but were unconvincing to some. New survey crews had been busy laying out the township lines north of Detroit in earnest since 1817, likely keeping Detroiters informed on their more encouraging findings when they returned for supplies.[39]

INSIDE INFORMATION

The usual meeting places for all levels of the social ladder were taverns, which really functioned as unofficial community centers. Traders, sailors, merchants, clerks and everyone in between could find news and gossip and even make deals at the local public house. Official news and notices could be had through the *Detroit Gazette* newspaper, published weekly. The question of what lay in the interior was a topic of interest that picked up steam when the lands were opened in 1818 and migration pressure built. As reported by the *Gazette* in November 1818, in addition to Governor Cass's expedition, "others" had been doing their own exploring in the wilderness.[40]

In spite of the appearance of selflessly acting for the public good, the Cass excursion was a scouting trip to find the best site for itself. Within days of their return in October, before publicizing their findings, its members had formed the Pontiac Company, pooled their capital and completed their land purchase. This led to a flurry of activity on the trail in the coming months. Records of land claims in Oakland County show that the progression of land sales moved north along the Saginaw Trail as settlers and investors sought to snap up choice parcels. The second wave of purchases fanned out away from the trail along lesser access routes. Land buyers wanted to be close to the best inland route, anticipating road improvements would follow.[41]

A STORY OF FORESIGHT AND FORTUNE

With the formation of the Pontiac Company, the time for tavern talk was over. It was time to act, and a scheme was quickly devised by three enterprising ex-soldiers in Detroit. They may have been hashing it over for months, but this plan was last minute, depending largely on the Pontiac scheme for success.

Elijah Willits (1792–1868) and his brother Isaac were born in Pennsylvania but lived in the vicinity of Detroit at the outbreak of the war, apparently having migrated with their parents, Thomas and Mary Allison Willits, sometime after 1806.[42] The brothers served in the Michigan militia under Antoine Dequindre to defend Detroit. When Governor Hull quickly surrendered, American soldiers were taken prisoner but paroled (released), provided they agreed not to take up arms against the British. Elijah and the rest of the Willits family somehow survived the deprivation and food shortage

faced by Detroiters during British occupation. After the war, he seems to have become connected to and possibly helped run a tavern with Catherine (Welch) Bailey by 1816. Catherine had inherited part ownership of a tavern at Griswold and Larned known as the Welch House. She was widowed twice (most recently when her husband Lieutenant Bailey was killed by Indians in 1814) and had young children. It is certain she knew Elijah Willits well, for he paid a hefty fifty-dollar fine in December 1816 imposed on her for selling alcohol on Sunday. Just weeks later, she and Willits were married in January 1817, making him owner of the tavern.[43] This would put him in an ideal position to hear gossip and ideas for investing in the public lands finally being properly surveyed.

John Benjamin Hamilton (1790–1868) was from New York and had served in the regular U.S. Army during the War of 1812, distinguishing himself at the Battle of Lundy's Lane and elsewhere. He was stationed in Detroit until his discharge in 1817.[44] Hamilton, an unmarried man, stayed on, likely taking on work in the busy territorial town. His later activities suggest he may have developed a knack for the transportation and supply business at this time, possibly bringing him into first contact with the owner of the Welch House, Elijah Willits.[45] Or perhaps he had known him during the war. In any case, he definitely became connected with a third man: John West Hunter (1792–1880), who had come with his brother Daniel to Detroit in March 1818. Within a year's time, Hamilton had married Olive Prindle, sister to John West Hunter's wife of many years, Margaret Prindle Hunter. His brother Daniel married a third Prindle sister, Sarah. Thus, the Hamiltons and Hunters were connected by marriage from an early date.

The Prindle sisters originally came from New York City. John and Margaret had their first child in 1812 near Albany. During the war, Hunter served in the New York Militia. Afterward, his entire family, including parents, relocated for a short time to Auburn, New York, halfway to Buffalo. Like many others from small farm communities, the Hunters migrated as an extended family unit to help ensure joint success in establishing wilderness homesteads.[46] In March 1818, he and Daniel crossed Canada by sleigh (an efficient way to travel the distance in winter) to prepare for final migration to Detroit. The brothers probably found lodgings and plenty of tavern talk as they inquired into land settlement. Perhaps they became acquainted at this time with John Hamilton and Elijah Willits at the Welch House. Perhaps they knew Hamilton from New York.

In any event, the beginnings of a plan may have been in place because in July, their father, Elisha Hunter, was on the way to Detroit by schooner

John West Hunter (*above, left*), John Hamilton (*above, right*) and Elijah Willits (*left*) purchased adjoining land along the Saginaw Trail, cornering the market on traffic going to and from the new town of Pontiac. *Birmingham Museum.*

with the rest of the family, including a very pregnant Margaret Hunter. Their third daughter was born in Detroit in October 1818, around the time Governor Cass was exploring the Saginaw Trail and the Pontiac Company was being formed. The infant was a mere two months old when Willits, Hamilton and Hunter jointly purchased their land parcels on December 1 and December 2, 1818. They were clustered along the Saginaw Trail on prime lands halfway to the planned town of Pontiac.

LOCATION, LOCATION, LOCATION

The three men coordinated their purchases of three 160-acre parcels that intersected at the trail and shared access to the Rouge River. Located in sections 25 and 36 of Township 2 North, 10 East, this provided direct access to the only land route—and future migrant traffic—between Detroit and Pontiac.[47] Through canny foresight and a good dose of luck, the spot was ideal for their purposes. It lay on the high, dry and verdant table lands of what is now Birmingham, just at the end of a day's travel from Detroit after emerging from the swampy forest and bogs that had to be crossed north of Detroit. Pontiac-bound travelers had to pass this way at the end of the first day. Who wouldn't welcome a place to stay after the dank and mucky swamp and its ferocious mosquitoes? What horse or ox team wouldn't need shelter and fresh hay? What exhausted settler's wife wouldn't pay their last silver piece for a hot meal and dry floor to sleep on? Furthermore, the land was good for farming, and the Rouge River offered fresh water, fish, wildfowl and water power for milling or manufacturing. The site might even become a settlement in its own right.

Without an apparent binding legal arrangement, the three men agreed on who would have first, second and third choice of the parcels. Perhaps they drew lots or simply shook hands. When all was said and done, by nightfall of December 2, 1818, all shared alike in the land's potential, limited only by the strength of their determination. The site held a promise of prosperity that was soon realized, and it has continued to do so in the two hundred years since. It became the center of Birmingham, one of the most prosperous cities in the country.

Of the three landowners, only John West Hunter needed to make immediate provisions to house a large family. Fortunately, the winter of

The Rouge River near the Saginaw Trail offered fresh water, fish and power for mills.
Birmingham Museum.

1818–19 was exceedingly mild; no snow fell until March. This allowed the Hunter brothers to raise a log cabin by January. Soon afterward, the Hunter clan—including men, women, children and their belongings—made their way from Detroit to their new home in the forest as the first permanent residents in what became Bloomfield Township. However, with it being early spring, they came the long way on higher ground, first to the mouth of the Clinton River on Lake St. Clair to the village of Mount Clemens, upriver to the Graham settlement in what is now Rochester, along the river by east–west Indian trail to Pontiac and, finally, the final seven miles south to their log cabin on the Saginaw Trail.[48] Within a year, disputes over boundaries arose between the neighbors, and it was found that the Hunter cabin was actually on Willits's parcel. Hunter then built a fine frame house on his land along the trail in 1822, which is now preserved as part of the Birmingham Museum.

THE SAD STORY OF BENJAMIN PIERCE

The Willits-Hamilton-Hunter parcels came together at what is now downtown Birmingham. The fourth parcel where they intersected was not on the trail but was good farmland. The Rouge River also crossed the parcel with a fine mill site. It was purchased a month later on December 30, 1818, by Captain Benjamin Kendrick Pierce (1790–1850) of Mackinac Island. He made the difficult trip in the dead of winter to the Detroit land office to enter the sale. It is reasonable to assume that Pierce had some foreknowledge of the property, but what and how are open to question. News about the planned town of Pontiac had probably widely circulated, but unlike its investors, he intended to personally farm his 160-acre parcel. The site adjoining Willits, Hamilton and Hunter was perfect for his needs, but a series of misfortunes got in the way, and he never had the opportunity.

Benjamin Pierce's father (a Revolutionary War officer and later governor of New Hampshire) and brother (later U.S. president Franklin Pierce) were well connected in political circles. His two brothers-in-law John and Solomon McNeil were high-ranking officers during the War of 1812 and similarly networked. However, Pierce himself never seemed to be in the right place at the right time. Success, wealth and position all eluded him. His early military duties in a crucial period of cultural transition in Native American–U.S.

relations took an additional toll on him during his time at Mackinac Island. Before long, his life began spiraling downward, and he never seemed able to fulfill his dreams.

His first wife, Josette, was the only daughter of the famous Madeleine La Framboise, a wealthy Odawa fur trader at Mackinac. They were married in 1816 and had a daughter at the time Pierce bought his land for a future farm. However, in 1820, Josette died in childbirth, as did their infant, and Pierce became estranged from his Indian mother-in-law for personal and cultural reasons. His life changed dramatically as he went from marrying into a wealthy and influential Odawa family to implementing forced military Indian removals, first in Michigan and later in Florida. In what seems to have been a desperate attempt to marry well and soon, he also went from a traditional and abolitionist New England upbringing to marrying into a slave-owning plantation family in the Deep South. Two more wives died young, leaving him with many children to raise. Ultimately, Pierce died debt-ridden and without attaining the rank he desired, feeling somehow betrayed by his career-long loyalty to the military. And despite the hopes he shared with his Mackinac Island friend Dr. William Beaumont on an 1821 trip on the Saginaw Trail to see his land, he never was able to farm his parcel in Birmingham.[49]

TRAGEDY ON THE TRAIL

Yet another story that illustrates the sad twists of fortune is that of the 1825 axe murders of Polly and Cynthia Ann Utter. Elijah Fish and his brother Imri served in different New York Militia regiments during the war. By early 1819, Elijah had settled on the Saginaw Trail north of Willits. His brother Imri joined him and, like many others in the frontier, hired out his labor. In 1825, he was boarding with the John Utter family, tenant farmers with a cabin on the trail just a short distance from Elijah Fish's. Polly Utter's brother John Diamond was a nearby settler.

Imri reportedly had been subject to periodic "fits" since the war ended. Three days before the murders, he left after dark and was found in the morning several miles away on the trail to Detroit, completely naked, having strewn his clothes along the trail. He recovered somewhat at his brother's

over the next day but left again after dark and went back to the Utters' to get some letters and papers he had there, inexplicably walking off into the woods. When Elijah learned of this, he went to look for him by torchlight, hearing screams as he approached the Utter place. He found the two women had been horribly mutilated. When he encountered Imri, Imri threatened him with an axe. Elijah was able to get away for help, and Imri was apprehended. In the morning, Elijah's horse was also found mutilated. Fish confessed to committing the crimes and said he thought "it was his duty" to do so.[50]

Imri Fish was convicted by a jury of his neighbors and, "not having the fear of God before his eyes but being moved and seduced by the instigation of the Devil," found insane. He was locked up in the county jail, a log building in Pontiac, and Elijah petitioned for control of his estate.[51] Imri died in jail some time after his trial in 1826. How he came to his end is not recorded. However, the murders made a permanent mark on the community, resulting in the donation of land for a public burial ground, now Birmingham's historic Greenwood Cemetery. The land was given by local settler Ziba Swan, a doctor who, the story goes, had recommended Imri to the Utters. He is said to have felt responsible for the horrible deaths and wanted the Utter women to have a proper burial site.

But it was the misunderstanding or dismissal of Imri Fish's mental health problems that was truly responsible for the tragedy. He had been signaling serious emotional difficulties since the war ended nine years previously, to no avail. Whether from an inherited mental illness, unidentified medical problem or the destructive effects of posttraumatic stress, his story is just one example of the existence of suffering as well as prosperity on the Saginaw Trail.

Chapter 5
THE EDGE OF THE WILDERNESS

lthough the town of Pontiac was a busy settlement after 1819, the
Saginaw Trail beyond was much less known. Only native people and
fur traders used it when a land route was needed between Detroit and the
trading posts and Indian villages to the north. The landscape along the trail
northwest of Pontiac was dotted with delightful lakes, ponds, springs and
streams whose individual characteristics were quite varied. They included
foul-smelling sulphurous lakes, cold mineral springs and even a soft-water
lake that became a washday destination for local settlers' wives because it was
so easy to launder clothes there.[52] Saline waters of salt seeps could also be
found, a necessity for wild animals and people alike and especially important
for early settlers. Singularly beautiful wildflowers grew throughout the area,
including many varieties that had never been seen by easterners before. The
waters teemed with fish and waterfowl of every type. The woodlands were
varied and full of birds and wildlife. Strawberries, bog cranberries and other
wild berries grew in abundance, and honey trees could be found at every
turn. The gently rolling hills were beautiful to the eye and offered plenty
of rich soil. It was a settler's paradise. Except for one thing: the Saginaw
Chippewa still roamed freely there.

The Chippewa (Ojibwa) Indians had been in Michigan for hundreds
of years. A large group remained in the far north, while another group
intermingled with the Odawa (Ottawa) and other Anishnaabe tribes in

lower Michigan, developing their own regional dialect and culture. Their traditions told of expelling the Sauk tribe from the Saginaw River Valley long ago. Since then, they had established seasonal patterns of travel to make maple sugar, plant, harvest, fish and hunt. They dispersed in the winter from large summer villages to smaller extended family groups or clans until the early spring, when they gathered in large numbers for maple sugar making again.

The French who came to Michigan were seen as good trading partners. Culturally, exchanging gifts and intermarrying meant that the French formed kinship bonds and gained favored trading status. In return, most French traders adapted to Indian culture without attempting to change it. When the British came, being enemies of the French, they naturally became the enemies of the native tribes. In simple terms, this meant mortal enemies that must be destroyed to the last man, woman and child. The British were equally as brutal to the indigenous tribes.

After the French were defeated and withdrew from Michigan, the Anishnaabeg were faced with new trading partners in the British and a different kind of white man who was uninterested in intermingling with the native people. The British continued the trade much as before, however, and eventually, the relationship stabilized. Later, when conflict arose between the British and Americans during the Revolutionary War, the British enlisted Native Americans as allies facing a common enemy. They offered gifts and payment, food for their hungry people and plunder for their warriors. But most importantly, they offered protection against the Americans who wanted what the British did not—to take Indian lands away.

Close Encounters

The American threat became more immediate when settlers began pushing through borders and colonizing the Northwest Territory. "Little Turtle's War" (the Northwest Indian War) of 1785–95 was an attempt to resist these incursions and push back. The British aided Indian resistance, and some tribes were especially willing to go to war against the hated Americans, including the Saginaw Chippewa and other Ojibwa. Even after the changes brought about by the 1807 Treaty of Detroit and the War of 1812, feelings were little changed among many of the Ojibwa

people when they were forced to deal with Americans.[53] The Americans made matters worse by aggressive policies and downright dismissal of native culture and language. The approach was to dominate, educate or eliminate the indigenous tribes. Yet settlers purchasing southeast Michigan lands in 1818 were in little danger from the majority of Indians they might encounter, who continued to follow seasonal movement patterns and, once a year, took the Saginaw Trail to Detroit for treaty payments. Small bands of Saginaw Chippewa camped from place to place and, for the most part, avoided settlers.

If there was trouble, it was usually because of whiskey and the insatiable hold it had on many native people. Local tribes had no previous experience of alcohol before European settlement and lacked social and behavioral controls on consumption, often drinking until fully intoxicated, leading to disabling addiction. Traders had known this since the eighteenth century and offered cheap whiskey in return for furs. Whiskey was also a staple of settlers, who often made their own. An addicted Indian desperate for *usquebah* (good whiskey) knew that he only needed to find the nearest log cabin. Many confrontations occurred between settlers and Native Americans who demanded whiskey and could become violent if refused. In the minds of many potential homesteaders, to settle in the isolated lands beyond Pontiac was to put one's family at risk of such dangerous encounters.[54]

OTHER DANGERS

The wilderness was bountiful, but in addition to unpredictable Indians, it was the world of wolves, wildcats, bears and venomous snakes likewise struggling to survive. Livestock, usually left to wander to forage in the woods, might be easy prey to a hungry predator. Bears and wolves commonly prowled outside settler cabins at night, looking for ways to get at the humans inside. Wolves were such a threat and so terrified settlers that a hefty bounty was paid for their pelts, such that wolf hunting became a secondary income for some and the gray wolf soon disappeared.[55] Another fearsome creature was the Massasauga rattlesnake ("Michigan rattler"). Its native environment was near wetlands, where tall marsh grass grew. Marsh hay was nutritious fodder and sought after for livestock, but if a grazing

Left: The venomous Massasauga rattlesnake was common in the marsh grass of Michigan wetlands. Pioneers learned to wrap their legs in twists of grass to prevent deadly bites. *Wikimedia.*

Below: Wolves preyed upon livestock and sometimes humans in the Michigan frontier, resulting in a bounty for their hides. The gray wolf soon disappeared from its natural range in southern Michigan. *Library of Congress.*

DEADLY ATTACK OF A WOLF UPON A MAN, AND HEROIC CONDUCT OF THE MAN'S WIFE.

horse or farmer disturbed a Massasauga, its venom was deadly. Pioneers quickly learned to protect themselves from the knee down, wearing heavy boots or, if they had none, thick braids of grass around their legs to keep the fangs at bay. If bitten, the only remedy, it was said, was a native cure, and despite their fearsome reputation, Indians regularly came to the aid of stricken settlers.[56]

A more insidious enemy could also invade to steal the life from an unwitting victim. Disease did not discriminate among humans and was a threat to city and country dweller alike. With no understanding of the germ origin of sickness or conditions that spread disease, entire families could be wiped out by the unchecked ravages of infection. Areas of dense population experienced devastating death from cholera in 1834 and later, spreading more quickly with improved transportation and increased contact. Less epidemic but just as deadly were typhus, influenza and other fevers. Michigan settlers almost universally succumbed to ague, a warm-season disease that could bring an entire family to its knees with periodic sweats, violent tremors and exhaustion. People of all ages could die from this inexplicable sickness. It was so incapacitating that the summer harvest might be left to rot in the fields because no one could bring it in. Often worse near marshes and wetlands, the ague was thought to be caused by miasmas, or bad air from swamps. In reality, it was malaria, a malady first brought to Michigan by people from the South and then spread by armies of *Anopheles* mosquitoes to infect the frontier population.[57]

By far the most deadly and frightful infectious disease was smallpox. Europeans who carried the disease often had acquired some resistance to it, which offered some protection in the white population. Those who had survived were easy to spot; the ravages of the painful disease left pockmarked scarring on their faces and bodies. When smallpox found the vulnerable indigenous populations, it killed thousands, sometimes leaving only a few survivors among hundreds of dead bodies in an entire village. Outbreaks of smallpox were further spread by native people who fled to relatives in other locations, unknowingly carrying death with them. The Saginaw Chippewa tribe was devastated by smallpox in 1837. Two-thirds of the population died.[58]

A Bright Light in the Dark Woods

Despite the dangers, the wild frontier still had appeal for a former military officer and merchant who was determined to make a good life for his family and leave Detroit and his troubles behind. He found peace and created a haven in the forest, welcoming travelers on the wild way to Saginaw with surprising civility and warmth.

Even before Lewis Cass made his exploratory trip up the Saginaw Trail, forty-four-year-old Major Oliver Williams and Calvin Baker, Jacob Eileet and Colonel Beaufait set out from Detroit on horseback in the early autumn of 1818 with a French guide.[59] Although the initial surveys claimed the land was interminable swamp, recent survey teams who were running lines every six miles reported otherwise. The Williams party wanted to see for themselves. They explored the Saginaw Trail another day's travel beyond the Huron (Clinton) River, where they encountered some of the most unexpected and beautiful landscapes they had ever seen. Instead of barren sands and fetid swamps, they found lush vegetation and rich soil, with clear, pure lakes and oak openings. They gathered samples of flowers and shrubs to take back with them as evidence of the quality of the soil. Williams's triumphant return and glowing report—with proof—no doubt spurred the determination of Cass to do his own official investigation a few weeks later, which led to the founding of the town of Pontiac. In the meantime, Major Williams and his brother-in-law Alpheus Williams took their wives, Mary and Abigail, back up the trail to make a final decision together. This was a bit unusual, and the women were later touted as the first white women to see the interior of Oakland County.[60]

Williams selected 320 acres of land in the lakes district a few miles beyond what became Pontiac's location. During the warm winter of 1818–19, while Mack was building at Pontiac and Hunter at Birmingham, Williams set out with a team of horses and three men. They had to clear the woods in some areas to get the horses and provisions through. Unlike other settlers' hastily built cabins, his was a large and comfortable hewn-timber home. It was a twenty- by fifty-foot, one-and-a-half-story dwelling on the south side of a lake dubbed Silver Lake and his holdings, Silver Lake Farms. Alpheus Williams and his son-in-law Archibald Phillips settled their families three miles farther, where the northern branch of the Clinton River crossed the trail.[61]

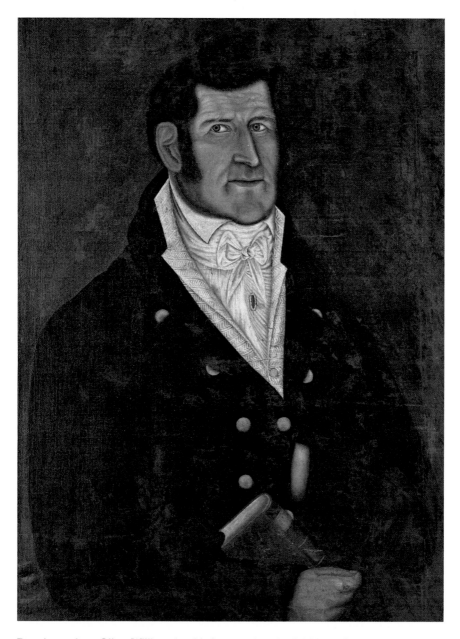

Detroit merchant Oliver Williams lost his fortune when the British confiscated his ship during the War of 1812. He started over again in the wilderness and became blood brothers with the notorious Chief Kishkawko. *Detroit Historical Society.*

WAR TAKES ITS TOLL

Oliver Williams (1774–1834) was a singularly interesting pioneer whose reputation for hospitality and geniality grew as the Saginaw Trail became more traveled and whose children continued to shape the growth of the entire area. But his Michigan legacy really began years earlier. In 1808, Williams established a successful business presence in Detroit, with a mercantile concern, fur trade and tavern. He regularly made the trip to Massachusetts for goods and supplies and to see his wife, Mary, and nine children. By the winter of 1810–11, he was able to build one of the first vessels on the Great Lakes at a shipyard on the River Rouge near the Detroit River. Christened the *Friends Good Will*, his 101-foot, forty-seven-ton square topsail sloop was a great improvement over the existing lake canoes that dominated the supply commerce on the Great Lakes. She would be able to take the Detroit-Mackinac–Fort Dearborn (Chicago) water route quickly and efficiently to supply the American forts en route and bring back cargo. She would be a great advantage over the bateaux rowed by voyageurs.[62]

The sleek *Friends Good Will* was in service for little more than a year when war with Great Britain broke out in the summer of 1812. Williams was en route from Fort Dearborn when war was declared. When he reached Fort Mackinac, the British had already taken the island but lured him into the harbor by flying the American flag. His ship and her military supplies were confiscated as a prize of war, and he and the crew were taken prisoner. Although he was paroled, his ship was not. The British renamed her *Little Belt* and put her to work as a sloop of war, outfitted with three guns and sent to join the British fleet in Lake Erie. The next year, she was retaken by Admiral Perry in his victory against the British in the Battle of Lake Erie.[63] She never made it back to the hands of her owner though; after a storm, she was stranded on shoals off Buffalo and torched by the British when they burned the town on December 31, 1813.

After the war, Williams sought compensation from the United States for his losses. In addition to his ship and investment in U.S. supplies, he had incurred other costs, such as paying ransom to save half a dozen people from Indian massacre at Detroit. It was to no avail; he never recovered more than a pittance. In 1815, he moved his wife and family from Massachusetts to Detroit, and in 1818, he sold his business interests to start a whole new life as a settler far out on the Saginaw Trail. His four grown sons helped him establish his homestead.[64]

Oliver Williams's smart little mercantile vessel, the *Friends Good Will*, was confiscated by the British during the War of 1812 and burned, but an exact replica sails the Great Lakes once again. *Michigan Maritime Museum.*

But Oliver Williams became Saginaw Trail legend for reasons that had more to do with his humanity and good sense than economic prosperity. He created a hospitable haven not only for his family but for everyone who traveled the trail, who were often warned that his was the last vestige of civilization before Saginaw.[65] Often overlooked for its significance, however, is that Williams alone among whites was able to befriend the notorious Chief Kishkawko of the Saginaw Chippewa, in fact being adopted, with his family, into the tribe. This is especially noteworthy because it sheds light on the character of both men and how they reached a personal understanding that, unfortunately, did not extend to their respective cultures.

THE DREADED KISHKAWKO

Kishkawko (the Raven or the Crow) (circa 1770–1826) is the most commonly mentioned Native American in Michigan settlement-era accounts for one reason: he inspired the greatest fear among pioneers.[66] He was powerful, ruthless and utterly opposed to American settlement. He knew from an early age that Americans did not want to share the land; they wanted to take it. As a young man in the 1790s, he went on raids to Ohio with his father, Meuetugesheck (Little Cedar), where they kidnapped a settler boy named John Tanner to be adopted in their family in place of a son who had died. In Tanner's account, Kishkawko, although also described as "cruel," had called him little brother from the outset and saved his life when another Indian sought to kill him.[67] Kishkawko proved to be a proud man who demanded respect but also valued kinship ties. He also, however, was subject to violent alcoholic episodes.

Little Cedar was a chief of his Saginaw Chippewa band and was a signatory to the 1807 Treaty of Detroit, but his son Kishkawko never acquiesced to treaty agreements and was vehemently opposed to the Treaty of Saginaw in 1819.[68] Afterward, Kishkawko continued to use the Saginaw Trail, frequently going to and from Detroit accompanied by others from his tribe. He seems to have never accepted that his people's lands had been lost to their enemies. Defiant and resentful, he terrorized settlers along the trail, threatening them, beating on some of them and taking their food and livestock. When he encountered Oliver Williams at Silver Lake, things took a different turn.

Shortly after the Treaty of Saginaw, Kishkawko and his band camped near the Williams homestead and came to the cabin demanding a large quantity of flour and pork. Williams did not have what they wanted but produced a peace pipe to smoke instead and, with an interpreter, conferred with the chief and some elders. Williams offered "what the Great Spirit had given us from the earth"—corn, potatoes and pumpkins he had growing in the field—and told them they were welcome to take what they needed. Kishkawko sent members of the tribe to gather the food and then named Williams "Che-Pontiock" (a designation of importance) during a solemn pipe ceremony with elders of his band. Ritual greetings were followed by the chief's pipe bearer passing Kishkawko's and Williams's pipes to everyone in turn, the chief declaring that Williams was his brother and his family belonged to Kishkawko's people. Oliver Williams duly concluded the rite with the offer of tobacco to each elder and a larger portion for the chief, as

well as more for the tribe, a demonstration of understanding and respect. Thereafter, none of the Williams family was ever accosted or troubled by the Saginaw Chippewa again. As for Kishkawko's habit of stealing food from other settlers, later events suggest that he took livestock to feed his people, expecting it would be replaced and deducted from his treaty payments. Notably, when Alexis de Tocqueville visited Silver Lake in 1831, Williams expressed that he felt safer around Indians than most whites.[69]

But Kishkawko's uncontrolled drinking and violence continued, although directed more at native people than settlers. Even so, the white population of Detroit must have breathed a collective sigh of relief when Kishkawko killed an Indian man there in 1826 and was arrested and sentenced to hang. Being bound and hanged was humiliating for many Native Americans, but death itself was not. On the night before the scheduled execution, three of Kishkawko's wives were permitted to visit him in his jail cell. In the morning, he was found dead, having drunk a poison concoction they provided him.[70] During his life, Kishkawko, the Raven, had seen many changes as the Americans took away his tribal lands and dignity. He had suffered many losses, not the least of which was his authority and the hope of a bright future for his people. In the end, however, he remained master of his destiny and refused to let his enemies also take his life.

Chapter 6
TWO TRAILS

At the end of 1818 and early 1819, a pioneer drama was playing out on the twenty-five-mile-long trail between Detroit and the town site of Pontiac. Its outcome would seal the fate of small-time farmers and homesteaders who were betting everything they had on land parcels along the last half of the route to the new town. They had everything to lose because they had everything in the game. And the game was road access—or what we think of today as transportation infrastructure.

Good roads were essential on the frontier for military movements and to build the settlement economy. Farms that hoped to produce surplus for profit needed to get their products to market; the faster and more reliable the access, the faster the route to prosperity. An isolated farm with no easy land route would never be more than a subsistence homestead. To diversify, frontier settlers dabbled in a bit of everything—most often, farming, small-scale manufacture and the mercantile trade. And if you were on a transportation route, there was also the market that went by your door.[71] On the Saginaw Trail, that market was new migrants.

After log dwellings, taverns were the next likely buildings to be built on the trail. Like their counterparts in the city, taverns were the wilderness version of a community center and meeting place, a source of news, food and drink; a place to do business; and even a location for holding religious and social functions. Taverns were especially successful at points where a road diverged or just before or after difficult stretches. In territorial Michigan, taverns were licensed and carefully regulated to ensure basic traveler needs were properly accommodated. Travelers sought good roads, and taverns sought travelers.[72]

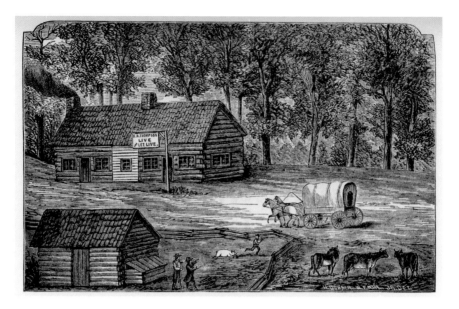

A welcome sight on the frontier trail was the tavern, where travelers could rest, get news, find a bed or have a simple meal of potatoes and pork. *Nowlin*, Bark Covered House.

A NEW ROAD TO FOLLOW

The fall of 1818 brought a cascade of events in swift succession that just as quickly shaped the future of the Saginaw Trail. After what had been a slow start to the opening of land sales in July, in September, the Williams party explored the trail beyond the Huron (Clinton) River and brought back their good news, quickly making plans to locate there. Cass's expedition followed, returning in late October, with many of the party forming the Pontiac Company and purchasing land for the town in the first week of November. In December, Willits, Hamilton and Hunter purchased their parcels halfway on the trail to Pontiac, and just days later, Cass signed a territorial act to "establish a road" to the planned town, soon to be followed by a proclamation of the new county of Oakland and the ultimately naming of Pontiac as its seat.[73]

The Detroit end of the road would follow Woodward Avenue to the city's northern boundary, near what is now Six Mile Road. From there, a commission would lay out the highway route to link Detroit and Pontiac, ostensibly as a public road but with obvious military value. Stephen Mack

and Shubael Conant took the lucrative contract for the six-mile-long Detroit portion, starting in January 1819. They built a well-made timber turnpike, taking almost two years to complete. Meanwhile, troops from Detroit under Colonel Leavenworth started a "corduroy road," or causeway, at the city limits where the Mack turnpike would leave off. They built it hastily with trees felled along the route, laying logs of all sizes crosswise over a swampy stretch, filling it with trailside mud and debris. The result was an awkward and uneven surface that deteriorated after the first rains into something even worse, giving this section of road a cursed reputation for years to come. Travelers were forced to dismount horses and wagons to find footing among the lumpy and slippery logs as best they could. Nearby, the original trail off the causeway was often the lesser of two evils, as travelers made their way through dank forests, sinking in mud with each step or jumping from spongy hummock to spongy hummock, often carrying a child and sometimes stopping to get a cart or animal unstuck.[74]

Do It Yourself

As all this activity got underway, a group of "actual settlers" midway up the trail in the Willits-Hamilton-Hunter vicinity became alarmed. There had been talk that the road to Pontiac would cut a straight line as the crow flies from Detroit, which could bypass them on the old trail that twisted and turned according to the landscape. They acted quickly to protect their investments and formed their own road crew. Setting out in January 1819, they began at the planned terminus of the military causeway, cutting a road that closely followed the old trail, hoping to preempt any alternate route. Their crew of nine included Rufus Hunter (brother of John West Hunter) and others who were already building or planning homesteads halfway up the trail. It was a remarkably mild winter that made for good building conditions.[75]

The appointed road commission also got started. It was composed of John Hunt, Ezra Baldwin and Levi Cook, all Detroiters who knew one another well. They had founded churches, partnered in business, sat on boards together and were involved in local politics. They contracted with surveyor Horatio Ball to lay out the road sometime in 1819. As it happened, Ball was the brother-in-law of Ziba Swan, a settler of note

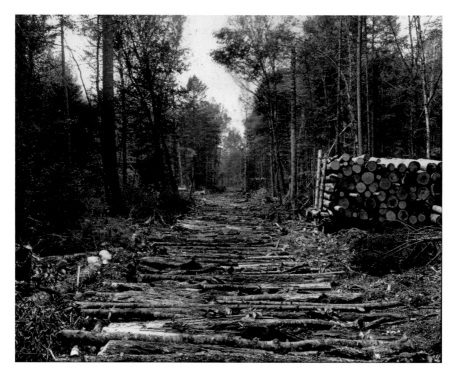

Corduroy roads were composed of logs laid crosswise to cross swampy wetlands and were a nineteenth-century road type used at many points along the Saginaw Trail. *New York State Archives.*

who also bought land near Willits, Hamilton and Hunter. Furthermore, a member of Ball's survey crew, Hervey Parke, had a brother Ezra who shortly joined the others on the trail halfway to Pontiac. They all stood to benefit from the government road passing their way. However, these family connections seemed to have no influence in the mind of Horatio Ball. His preferred route took a decidedly different turn.[76]

Eight miles from the Detroit River, the trail led northwesterly across the Base Line of Wayne County and into Oakland. About a half mile farther, the main Indian trail split in two before rejoining itself three miles farther. Neither branch spared the traveler from what some considered the worst swamps on the trail. The westward side navigated through heavy marshland around a large cranberry bog, while the east side led around two marshy lakes on a narrow sandy ridge until a third branch split off it and headed due north. The east side then turned to rejoin the west side as the trail worked its way out of the wetlands and marsh, crossing several streams in the process.

The branch that led north was the Paint Creek trail, leading to what became the village of Rochester.

This trail junction was of great importance, as it marked the land route connection of two major watersheds. The Rouge system (reached via the Saginaw Trail to the northwest) flowed southerly to the Detroit River, and the Clinton system (including the Red Run Creek) flowed easterly to Lake St. Clair. Their respective ecosystems featured different natural resources, connected by the Paint Creek path. Unfortunately, they all met in an area of lowlands and floodplains. To navigate such often-flooded areas, the native people used trail marker trees. These were shaped by hand as saplings into

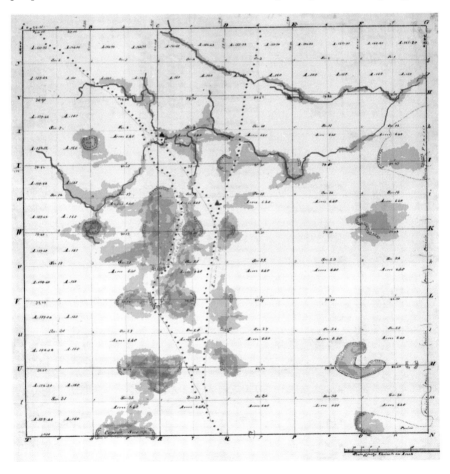

The Saginaw Trail route split around bogs and marshy lakes in Royal Oak Township before re-converging. The Paint Creek Trail branched to the north, leading to Rochester. *Map by author from original Joseph Wampler survey map.*

The Indian trail system used specially trained trail marker trees as navigational aids. They marked sudden changes in the route and showed the way across swampy terrain. *Milan Historical Society.*

characteristic forms as wayfinding aids and were used throughout the Great Lakes. Such a tree was located along a portion of the trail that warned travelers of a sharp turn after crossing the Red Run Creek to continue on the main Saginaw Trail. The tree remained as the land around it changed; by the mid-twentieth century, the wetlands were gone, leaving it little more than a curiosity.[77]

Foot trails and marker trees were of only passing concern for settlement-minded pioneers. Their roads needed to be wide to withstand heavy wagons and to be navigable all year. Road technology of the time was not particularly sophisticated, however. City streets might be paved with cobbles or flat bricks, but often they were dusty dirt tracks full of manure and vile beyond imagination when it rained. Flat sawn boardwalks were sometimes built at the doors of buildings or as short walkways in town, but country highways were of the corduroy type and did not come cheap. In the frontier, materials were not the problem, but to last more than a season or two, a turnpike required constant maintenance, and that took money, labor and organization, all scarce in the wilderness. All this was understood by the Saginaw Trail landowners in 1819; the strategy of building their road ahead of Ball's survey should have worked to their advantage by saving the government time and money and becoming the preferred route. But Horatio Ball looked at things differently.

THE BALL LINE

Ball laid out a straight road out of Detroit until he reached the split trail area in Oakland County. He followed the eastern path on the sand ridge toward the Paint Creek trail. Just shy of where it branched off, he blazed his mark, "H," on a prominent oak tree, using that point to sight the route in a straight line to Pontiac. This "bee" line became known as the Ball Line, and it ran about three-quarters of a mile east of the original trail for ten miles before rejoining it near Pontiac, bypassing the majority of the mid-trail settlers. But it was the official route adopted for the road by proclamation in December 1819. Others stood to gain, however; road commissioners Cook and Baldwin had invested months earlier in parcels along the Ball Line they recommended.[78]

The government road to Pontiac was built in sections over the next decade or so along the Ball Line, but the settlers' road, sometimes called the "old road," continued in use, meaning there were two viable paths to Pontiac. Numerous taverns sprang up to capture migrant traffic on the road, with prime locations being before the split, where everyone had to pass. Even so, word of mouth spread among travelers so that they would go farther to reach taverns with good reputations. Many settlers directly on the trail opened their homes to passing migrants as a side business. They included Elijah Willits, John West Hunter and John Hamilton and, a little farther north, Asa Bagley and William Morris. To entice new settlers to locate near them, they quickly built mills and manufactories and established schools and churches. Hamilton induced migrants to stop at his place by meeting them in Detroit with an oxcart to transport them to Pontiac. He became so well known that what became known later as Birmingham was first called "Hamilton's."

WHATCHACALLIT

For many years, there were no villages in Michigan's interior; maps initially noted small settlements by the taverns or settlers there. When townships were formally organized in the later 1820s, they might be given names loosely descriptive of the landscape, such as "Bloomfield" or "Waterford," and settlements that followed could take that name. But when post offices were formalized soon after, stations were commonly named by the local

postmaster, which usually determined the name of the village thereafter. No matter its name, a settlement's viability depended on people, and people depended on transportation. If access changed or never developed, a promising community might cease to exist.

The Ball Line is an example. After it was built, the two roads to Pontiac continued in simultaneous use. The settlements of Chittendens and Fairbanks Corners grew along the Ball Line, while Birmingham and Bloomfield Centre became established on the old road. In 1838, when the government was seeking to establish an official post office, competition was intense between the two routes; community survival might depend on it. Birmingham was victorious, and the mail route was established on the old Saginaw Road. The traffic on the Ball Line diminished and Chittendens and Fairbanks with it. Eventually, the Ball Line itself began to disappear, although vestiges of it still survive in some local roadways.[79]

However, back at the Saginaw Trail near the origin of the Ball Line and Paint Creek trail, homestead land sales were hot and commercial opportunities were growing. Taverns did a good business, and settlers began to build. The general prominence of oaks and Ball's survey landmark, "H" on an ancient oak, led to the area becoming known as Royal Oak. Although the legend attributes the moniker to Lewis Cass on the 1818 expedition, the name "Royal Oak" emerged much later as the official township name in 1832, and the village took that name when it was platted in 1836. Up to that point, the map notation for the cluster of taverns and dwellings in the area was for a local tavern—Bronson's. But Bronson's was not the oldest or the most famous of the taverns in the vicinity. There was another that was both and was so exceptional that it became a legend during its own time, as did its proprietor.[80]

THE ROAD LESS TRAVELED

Mary Ann Chappell was unique among women of the early Saginaw Trail. She was perhaps the first woman to purchase land in Oakland County, just four days after Congress set the price for public lands at $1.25 an acre in 1820. For several years, Chappell had been a tavern keeper in various locations along the old trail out of Detroit. Her fame spread far and wide; she was known to keep a good inn with excellent food and whiskey and

gave careful attention to the needs of patrons. She resented her nickname, "Mother Handsome," a reference to her heavily scarred face as a smallpox survivor. Even so, the name persisted, but woe to the traveler who said it to her face. Yet her kindness to travelers was legendary, and people also sought her out for her renowned medical remedies.[81]

She was said to have been a "camp follower" during the War of 1812, but although often confused to mean prostitute, the term more accurately refers to support personnel who moved with armies. Usually they were women, often the wives of soldiers, who earned a small income for cooking and laundry or caring for the sick and wounded. They had to be tough and capable, coping with temporary shelters and minimal supplies, battle risk and moving with the army at a moment's notice. If their husbands were killed, they may be forced to support themselves entirely.[82]

Chappell became known on the Detroit end of the trail sometime after the war. As a former camp follower, she would have been comfortable doing business with fur traders, Indians and ex-military. She was resourceful and widely skilled, successfully operating a frontier inn where supplies could be limited and patrons demanding. After 1819, she moved north to a log cabin just south of where the Paint Creek and Ball Line junction split the traffic, her reputation growing with new migrant business. By 1820, she had cash to purchase eighty acres outright and later built a frame house not far from the old trail. Sadly, the traffic on the trail fell away as the railroad came through in the 1830s, and though she continued as an innkeeper, she appears to have fallen on hard times. Local legend says she died impoverished. However, in the rough-and-tumble early days of the Michigan frontier, Mary Ann Chappell held her own, feeding and sheltering many a weary and hungry wayfarer on the Saginaw Road.[83]

FREEDOM ON THE SAGINAW TRAIL

Over the years, the area later called Royal Oak became a microcosm of the American melting pot. It was a welcoming community that counted among its citizens those of varied religious, cultural and ethnic backgrounds. Two of the earliest pioneering families who escaped slavery's hold included that of Hamlet Harris (1785–1880) and Gilbert and Elizabeth Hamer (1823–1913). Harris, a freeman, was one of only 261 African Americans

in Michigan and about 28 who lived outside Detroit when he arrived in 1830. He purchased farmland on the west side of the Saginaw Trail, by then an improved turnpike road. He himself was not a slave, but his family carried the emotional burdens of slavery in Georgia, where he bought his wife out of enslavement (she was reputedly the daughter of the governor). When the Harrises and their six sons came to Michigan, it was still a forested wilderness. Harris took the unusual measure of cutting a long drive through the woods, building his house back from the road. Perhaps this offered a sense of security or privacy. But hardly a recluse, Harris became an active part of the community. He never learned to read or write but helped fund the building of the Baptist church in 1839. After the Civil War, when he voted for the first time, he exclaimed in tears, "Now, I am a man!" He lived the rest of his life in Royal Oak until the age of ninety-three.[84]

Gilbert and Elizabeth Hamer came as fugitive slaves from a Kentucky plantation to Canada around 1850. It is not known what their original names were, but Gilbert changed his name during the journey to avoid

Former slave Betty Hamer escaped to Michigan with husband Gilbert and bought land in Royal Oak. They raised vegetables and chickens and sold surplus produce. *Royal Oak Historical Society.*

recapture by the ever-present bounty hunters who trolled the streets of Detroit, a Mecca for escapees. In spite of the danger, Gilbert crossed the river to find work in Detroit while Elizabeth "Betty" awaited the birth of their first child in Canada. Eventually, they made their way to Detroit together, but soon after, Gilbert walked up the Saginaw Road looking for work. He found it at the Starr farm on the Ball Line, and they were able to save to buy seven acres of land. They lived in unsettled times but worked hard and became part of the community. They joined the same Baptist church as the Harrises. They raised vegetables and chickens and were able to sell surplus produce. When Lincoln emancipated all slaves in 1862, it must have alleviated a great deal of anxiety about their legal status. In 1865, however, Gilbert brought the shocking news back from Detroit that the president had been assassinated. The Harrises were devastated. Like many Americans, their lives were forever changed by the event.

Betty and Gilbert remained in Royal Oak, where she died at the age of ninety in 1913. During her long life, she had been born into bondage; taken from her family and sold at a slave market; escaped as a fugitive; changed her identity and fled pregnant to the unknown North; given birth alone in a foreign place; and hid with her husband in a wilderness settlement until finally emancipated, when she could feel safe at last in her new home. But unlike Gilbert, she never earned the right to vote, which was denied all women until 1920. Even so, Hamer raised her children in Royal Oak and was an accepted part of the community in the life they built along the Saginaw Trail.[85]

THE END OF THE FRONTIER

When the railroad first came to Oakland County in the late 1830s, the new transportation technology transformed the landscape, the settlements, commerce and the lives of its residents. Those who owned property along the route prospered from the economic benefits of direct access to such a powerful force for change. The village of Royal Oak was in many ways the gravitational center for rail transportation and development. Its location at the juncture of the two main transportation routes extending into the county, and the leadership and influence of its community, particularly Sherman Stevens, ultimately shaped the future of all the communities along the trail.

Just as the Indian footpath had determined the location of better roads and population centers, the railroad, in turn, sought to connect to those same people and places. Railroads would move people, goods and products more quickly, more efficiently and with greater reach, deeper into the undeveloped lands. This would transform the entire territory of Michigan even as it was becoming a state in 1837 and the economy was bursting at the seams. But it was not sustainable; in the midst of all this forward momentum, a banking crisis driven by land speculation, the Panic of 1837, cut short the government's more ambitious goals for Michigan.[86]

And not everyone was enthusiastic about railroads, with their fast and cheap means of moving products and people. Birmingham's John Hamilton depended economically on horse-drawn transportation and held out against selling his land for the right-of-way, stalling the railroad's link between Royal Oak and Pontiac for several years. Sherman Stevens finally negotiated an apropos "horse trade": a sawmill site in the timbered frontier settlement of Flint farther north on the Saginaw Trail in exchange for the right-of-way. Whether he was simply a shrewd businessman or yearned for pioneer life and the chance to shape another place, Hamilton took the deal and relocated to this forested wilderness where wolves and bears still roamed and the Indians had not yet disappeared.

INDIAN COUNTRY

The establishment of the town of Pontiac at their summer camp was just the beginning of many successive Indian displacements by American migrants, creating increasing pressure on the tribes to go elsewhere and the need for additional treaties to get more of their land. For a time, however, interior lands beyond the Williams homestead remained unexplored and unsettled by whites. The rivers and other waterways dominated the wild landscape, filled with sounds of forest birdlife and the occasional howling wolf rather than that of the settler's axe. These lands remained the domain of native peoples. The seasonal migration cycle continued much as it had before. The Saginaw Chippewa and Anishnaabe people gathered in large summer village camps where hunting, fishing and gardening could support larger numbers of extended families, followed by winter dispersal in small family groups to manage the leaner months. Traditional paths led to winter trapping and trading, although white settlers were increasingly encountered nearer Detroit, and where whites were more numerous, wildlife was scarce. Local tribes retreated deeper into a wilderness that remained unknown to settlers but continued as the province of indigenous people and their traditions.

The boundary line to Indian country roughly corresponded to the watershed boundary between two important river systems traversed by the Saginaw Trail. The Clinton River system flowed easterly, fed by tributaries such as the Paint and Red Run Creeks. The Oliver and Alpheus Williams homesteads were in the upper Clinton watershed, where numerous lakes

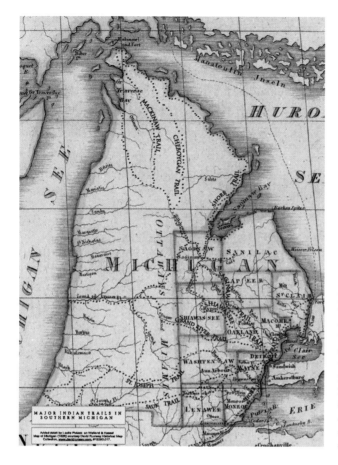

Indian trails connected villages, camps and cultural sites for the thousands of indigenous people who used them. Major footpaths became roads, then highways, and are now freeways. *Map by author from David Rumsey Historical Maps.*

and springs flowed from the rolling hills to form the main river and empty into Lake St. Clair. But only a few miles north lay the extensive Saginaw River watershed, which drained many hundreds of square miles that flowed away much farther north and east to the Saginaw Bay.[87] It was a complex system that included the Shiawassee, Flint, Cass and Titabawassee Rivers, as well as numerous other streams. The great number of waterways, wildlife and remote nature of the landscape allowed the Saginaw Chippewa to continue to trap and trade furs longer than those in other parts of southern Michigan. Crisscrossing trails and rivers led between interior villages and seasonal destinations.[88]

The white or biracial Métis traders knew the rivers and trails, too. They met the native people at simple streamside cabins where rivers and trails intersected. But, as they had been for centuries, fur traders were middlemen merchants, not farmers. They might marry into local tribes to gain trade

advantage but not to settle. They had one purpose only—to trade and make a profit, whether for themselves as independent traders or, ever more commonly, as agents of the monopolizing American Fur Company. Their lifestyle was simple and much like that in the wilderness camps of their Indian trading partners and relatives.

TRIBES, BANDS, CLANS AND TOTEMS

Traders who became prosperous learned the language and culture of the Anishnaabeg on the other end of the trading equation, especially the nature of their relationship bonds. This involved an understanding of extended family networks, sub-tribal groupings and social customs, which dictated protocol and were essential to grasping loyalties within and between tribes and with outsiders.

The Anishnaabeg are a large group composed of various Great Lakes tribes with shared language and customs. In early nineteenth-century Michigan, these were primarily the Ojibwe (Chippewa) in east and southeastern lower Michigan and the Upper Peninsula, the Odawa (Ottawa) of northwestern and western Michigan and the Potawatomi of south and southwestern Michigan. Tribal sub-groupings, then as now, are organized by clans, people who think of themselves as sharing the same ancient ancestor. They may not live near each other or know one another but are considered blood relations and members of the same *dodem* (totem), identified with an animal and common lifeways that distinguish them from other *dodems*. Bands consist of a number of related family groups that historically shared the same resources and a traditional physical territory, such as a river or bay. Bands lived together in summer villages and shared labor, raised crops and strengthened close kinship bonds. Within a band, individual family households might include extended family members of several generations.[89]

Traditionally, an individual's identity has many aspects: personal, clan, band homeland and tribal affiliation. The same person can be known by various names, which can change over time and can include a personal or spiritual identity, a name conferred by the clan and one that incorporates one's *dodem*. For example, on treaties, a chief's name might be spelled phonetically more than one way (depending on the listener) and may also

include another name, as well as a drawing of his *dodem* as his mark, all of which were true representations of who he was.

A final point is that the complex nature of Anishnaabe family relations is not analogous to that of nonnative culture. In the early nineteenth century, marriage bonds were easily formed and dissolved, and men may have had more than one wife. As it is taboo to marry in the same *dodem*, eligible partners may be from another band or tribal affiliation; and since some tribes are patriarchal and others matrilineal, there might be different approaches to family structure and authority within a clan or band. Furthermore, other members of the extended family or clan might be characterized as "brother/sister," "cousin" and so on, as a reference to the proximity and intimacy of the blood relation but not necessarily as the English language assigns those terms. The complex nature of Anishnaabe family relations contributed to the difficulty for early white settlers to understand and interact appropriately with the people of Indian country.[90]

THE COMFORT ZONE

Seasonal encounters with local bands was a universal experience of early Michigan pioneers. In some cases, frontier isolation led to mutual respect and assistance between the old culture and the new. White settlers might admire and trust the wilderness skills of local Indians and develop lasting friendships. Settler children were quick to learn the languages and customs through contact with native children. As adults, their accounts are observant and reflect more sensitive and accepting attitudes than those of other whites who had limited capacity or interest in learning native language and customs. Instead, narratives of these pioneers say more about their own superstitions and fears than offering an understanding of the Indians they encountered. Furthermore, few documents survive beyond settlers' accounts to provide insight into the historical Native Americans of the Saginaw Trail, and unfortunately, tribal documents are also scarce. Tribal history is largely dependent on oral tradition. Thus, little is known of the thousands of Ojibwa, Odawa and other Anishnaabe people who remain undocumented and unknown.[91]

As decades of the nineteenth century passed, Indians grew less numerous in Indian country. They succumbed to smallpox and cholera, retreated

Passing the Williams homestead, travelers entered into Indian country, where the wilderness was still untouched. *Wikimedia.*

farther north or were removed by force.[92] Prejudicial attitudes in the public mind began to lump all native people together, further reducing tribal, individual and cultural distinctions. "Indian" became ever more pejorative; indigenous people were increasingly seen by whites as foreign, strange,

dirty, lazy, poor, burdensome and, ultimately, condemned to entrenched prejudice and bigotry.

This situation was exacerbated by the completely different approach of Native Americans to the land and its natural resources. The American ideal of owning and controlling the land was foreign to the Anishnaabeg, who instead preserved natural resources by limited seasonal use. Tribal migration allowed plant and animal life to recover, maintaining balance and ensuring resources would be there in the future. In white terms, however, farming the land was the highest possible act of civilization. Indigenous people who couldn't or wouldn't settle and till the soil in a fixed location could never become "civilized" or become part of American society. This belief became deeply held and increasingly reflected in official policy, treaties, laws and attitudes toward Native Americans by the American government and its citizens. As settlement communities grew along the Saginaw Trail, local Indians who remained and tried to adapt were tolerated but often marginalized. They are sometimes portrayed in ways that characterize them as local curiosities, community mascots with white nicknames or objects of pity. Toward the end of the nineteenth century, a common view also emerged that saw Native Americans as disappearing along with the wilderness; the romanticized concept of the "noble savage" became popular in literature and American culture. Ultimately, neither position has contributed to an accurate understanding of Michigan's native people, whose past and present culture is still widely misunderstood by nonnatives.[93]

CHIEF OKEMOS (LITTLE CHIEF)

The story of Chief Okemos (circa 1775–1858) can be seen as a metaphor for the struggles of the Anishnaabeg to cope with American intrusion after the War of 1812. His life experience ranges throughout the Northwest Territory and spans the period before and after the war, several successive Indian treaties and the settlement of his homeland. It illustrates how American culture and institutions negatively impacted Michigan's indigenous people, altered their lifeways and reduced many to a mere shadow of their former selves.

Okemos (whose name was taken by a town near Lansing) was originally a prominent warrior of the Bear clan of Saginaw Chippewa who

distinguished himself in battles opposing American expansion in the years before the War of 1812. Most accounts say he was born at the Indian village *Kechewaundogining*, or Big Salt Lick (for the natural salt seeps there), on the Shiawassee River in the Saginaw River Valley. His band was associated with this area, which lay west and roughly parallel to the Saginaw Trail, north of Pontiac. "Okemos" is an Anglicized variant of *ogimaans*, meaning "Little Chief," reputedly due to his short stature of five feet tall. In some accounts, he is a nephew and in others a cousin of the warrior Chief Pontiac. This could be accurate in light of broad kinship ties and clan affiliation, since Pontiac, an Odawa with Ojibwa affiliation, had several wives and many children and lived throughout southern Michigan and northern Ohio. Or it could be that, as suggested by some accounts, Okemos was simply embellishing his life story as he recounted his battle exploits to white settlers in later life.[94]

As a young man, he was a respected and fierce warrior who was victorious in battle against the Americans in 1791 during Little Turtle's War but was defeated in the Battle of Fallen Timbers in 1794. He later followed the call of Tecumseh to fight the Americans at Tippecanoe in 1811, escaping when William Henry Harrison defeated the Indian allied forces. Like many other

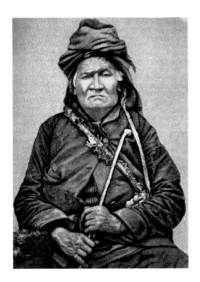

Warrior Chief Okemos of the Saginaw Chippewa was the sworn enemy of the Americans during the War of 1812 but acquiesced when captured, later becoming well known to Saginaw-area settlers. *ChiefOkemos.com.*

Saginaw Chippewa, he soon joined the British side in the War of 1812, not only for silver and glory, but also to defend his homelands. The British had warned the Saginaw Chippewa that the Americans were after their land. This provocation was met with fierce fighting by the Indians, who symbolically "cram[med] clay and sand into the eyes and down the throats of the dying and the dead [Americans]."[95]

For his leadership, the British made Okemos a colonel during the War of 1812, in recognition of which he often proudly wore a British coat with epaulets for later portraits. He fought in successful battles for the British until he and a small group of fellow warriors were overwhelmed by superior American forces at the Battle of Sandusky, Ohio, in 1813. The Indians were literally hacked to pieces, but Okemos and two others were found barely alive on the

battlefield. He had sustained serious saber wounds to his head, face and back, and his shoulder was cleft nearly in two. He survived but required months of care and bore many scars; some wounds never healed completely. As soon as he recovered sufficiently, he returned to fighting. His last battle was the Battle of the Thames in 1813, where Tecumseh was killed and Okemos was again injured. According to accounts, he appeared in Detroit at Fort Wayne in 1814 and declared that he would fight no more. With the intercession of Colonel Gabriel Godfroy, he was pardoned by Lewis Cass. Because of his warrior prowess, he became chief of his band, which now followed peaceful lifeways. They hunted and fished along the Shiawassee and Cedar Rivers, seasonally visiting Saginaw, Lansing and Detroit. His role became diminished in the 1830s as his people died of smallpox or were displaced by American settlement. As the years went by, he became increasingly impoverished but formed friendships among some whites and was fondly received by them; they remembered him trading baskets for food and shelter. As settlers plowed the lands he had roamed as a young man when they were still forest, he wandered among them and told stories of the war, to the delight of many a pioneer child. Despite his fierce resistance to Americans for much of his early life, he succumbed to the greater power of the forces of American settlement, clinging to his traditional way of life until it all but disappeared. In the last years of his life, he lost his wife and became nearly blind. He finally died in 1858, not surrounded by his people, as in the days of his ancestors, but in a white man's cabin.[96]

GRAND BLANC (GREAT WHITE)

The origin of the name of the settlement of Grand Blanc is not a French description of the place but, rather, of a person. He was a chief and signatory on the 1807 Treaty of Detroit, recorded as *Sawanabenase* or *Pechegabua*, but the French called him *Grand Blanc* (Great White) for his height and very pale complexion. He was a warrior of high regard who fought with Pontiac against the British in the late eighteenth century. His band was known for legendary hunting prowess and engaged in trade with the earliest French traders in the area. His son, the Fisher, continued as chief after him and was known to some of the early settlers. Their band frequently camped along the Thread River near the Saginaw Trail but by the early nineteenth century

avoided whites and the trail. They were little known to pioneers except through the place name of Grand Blanc. By 1825, early settlers (ignorant of the legendary warrior as well as the French language) had blurred both the history and the place name to "Grumlaw," remembering it instead for its swamp. Eventually, the swamp also lost its hold on memory when a causeway improvement of the Saginaw Trail made it more easily crossed.[97]

Many of the settlers of Grand Blanc seemed altogether mystified by the culture they were dispossessing, forming superstitious and "very strange ideas of the Indian character, and their doings, which has caused so many strange notions about the Indians by the early pioneers" that persisted.[98] These could take the form of frightening and fanciful tales of what was to them inscrutable Indian behavior. Lacking understanding of the language and culture, white settlers felt threatened by the sudden appearance of hunting parties or families heading down the trail to get annuities at Detroit. They were sometimes fascinated by Indian legends attached to physical sites but could be particularly ignorant and insensitive to sacred places, of which there were several in the area.[99]

One special place was called Nine Tracks, visible from the Saginaw Trail halfway from Pontiac to Grand Blanc. The slope was marked by seven to nine curious depressions that were carefully maintained by the Saginaw Chippewa, who always stopped to perform ceremonies when they passed. Legend told of a warrior, shot by enemies on the ridge, who ran or jumped down the slope, creating depressions at every step six to eight feet apart until he fell, leaving a final mark from his shoulder and hip. What the sacred significance of this site meant to the Indians, however, was never recorded.[100]

Another sacred place lay just north of the settlement of Grand Blanc. The trail crossed over the middle of a circular rise of grassy ground forty to fifty feet wide. The native people planted and maintained a mature ring of wild red and yellow plum trees that bore large and luscious fruit. But the spot was more than an orchard. Near the center of the circle was a tall stone, about four feet high, called *Bab-o-quah* by local Indians. They universally stopped to perform a somber ritual and smoke a ceremonial pipe.[101]

Jacob Stevens (father of Royal Oak's Sherman Stevens) was the first white settler at Grand Blanc in 1823, having moved up the Saginaw Trail with his family from Pontiac because they couldn't get title to the land they had settled there. When building his log cabin, he wanted stone for the fireplace. His son Rufus happened upon the *Bab-o-quah* site and dragged the stone to the cabin. When the local Saginaw Chippewa learned of its fate, they sent a delegation to get it back. Stevens made repeated offers to buy it instead,

which were flatly refused. He finally relented and returned it but was mocked and called "Bab-o-quah" by them ever after. Stevens was typical of the all-too-common and selfish white settler: as if this was not enough, he also built his cabin on a field the Indians used to grow crops for winter survival, forcing them to go elsewhere. Encounters like these made it difficult for the Saginaw Chippewa to coexist with white settlers who increasingly came to the area. Ironically, Stevens himself never purchased the land at Grand Blanc. Within a year, he abandoned the site and returned back east.[102]

WHITE MAN'S LINES

Native people in Indian country could encounter white men who engaged in actions that must have seemed rather senseless to them at first but which helped speed the loss of their homelands. The men came, especially in the winter, in small groups of four or five with odd metal instruments, looked out over the land and called out to one another, laying a chain and carving marks into trees. They removed brush, branches and even trees that were in the way of the lines of their chains. They began before dawn and worked until dusk and wrote in notebooks by the fire until late at night. These were surveyors, recording features of the landscape, mapping them and making it possible for the American government to sell Indian lands it had acquired by treaty.[103]

Surveying was an important scientific endeavor that depended on precise measurements and accuracy. In general, survey crews were composed of dedicated young men who braved weather, frostbite and near starvation. They fought off wolves, got lost in blizzards and fell through ice on rivers. A stubborn surveyor in northern Michigan in the 1820s named Thomas reportedly declared that he "would leave his bones in the woods sooner than leave his work."[104] By and by, they marked the wilderness and, in so doing, started the process that changed it forever.

Hervey Parke (1790–1880) was a young schoolteacher when he and his family migrated to Michigan, went up the Saginaw Trail and lived temporarily with John West Hunter and his family. While waiting for word on his government application to do survey work, he taught the settlers' children at the place that would become Birmingham. He worked on Horatio Ball's crew in surveying the Saginaw Road in 1819 and, not long after, purchased land near Pontiac, where he lived out his later years. His lifetime

of survey work took him far and wide, throughout Michigan and elsewhere, including large portions of the Saginaw Valley. He wrote entertaining accounts of his experiences, including encounters with pioneer settlers, Indians, floods and hurricane-force winds, incompetent surveyors and Michigan's forested Indian country. He described the landscape, the people, the food, the taverns and details of making a homestead cabin a home. His observations help provide human context for the people and the environment of the Saginaw Trail whose swamps he trudged, whose rivers he crossed and where he lived out his final days with little complaint of his lifelong hardships as a surveyor. Parke was respectful of the Indians he met, but he knew that with every step, their land was slipping away from them.[105]

Hervey Parke migrated as a young man on foot from New York and became a wilderness surveyor for much of lower Michigan. Most importantly, he wrote extensive accounts of his experiences. *Findagrave.com.*

Chapter 8

A TRADER'S LIFE

Although ceded to the United States in 1819, the former tribal lands of the Saginaw River watershed were lightly settled and remained the domain of the Saginaw Chippewa into the late 1830s. What few pioneers there were built cabins at likely sites on the trail that were easier to farm, such as where Indians had long kept the land cultivated. But the northern wilderness was remote, and it was difficult to travel all the miles back to Pontiac, no matter what time of year. It is for this reason that travelers along the Saginaw Trail such as Alexis de Tocqueville were warned that the Williams homesteads were the last bastion of civilization before Saginaw and discouraged from venturing farther. And most had little reason to; good, rich bottomlands were to be found in the Clinton River Valley. All an enterprising pioneer farmer had to do was to secure his claim and clear the trees, and prosperity would surely follow. Traveling might be necessary on the farther stretches of the Saginaw Trail for soldiers and traders, but for most, there was more than enough to do right where they were.

But even around Pontiac it was still the wilderness—forested, swampy in many places and the domain of prowling wolves and bears. Only traders were likely to be found off the main trails or at the remote cabins on rivers to the north. Although the heyday of Michigan's fur trade was fading, small-time traders in Indian country in the Saginaw Valley continued to do passably well for a time. They maintained the tradition of close relationships with the indigenous peoples and face-to-face business transactions and continued to bring the goods the native population was so dependent on. As

Independent fur traders traveled between Indian villages in even the coldest weather to collect furs and exchange trade goods. *New York Public Library.*

long as there were fur-bearing animals for Indians to trap, there were traders willing to exchange necessities for them.

Long-standing trading partnerships had become the foundation for Indian subsistence, but as the tribes were forced into treaties and relinquished their lands, the furs needed to acquire guns, blankets, ironware and other necessities became increasingly scarce. Payments for treaty lands were inadequate to sustain their way of life, and very few adopted agricultural practice on a fixed piece of land. Indian country still had the resources for them to continue their traditional lifeways—for a time at least. Some old-style traders were the half-Indian, half-French Métis who were comfortable in white and native cultures, but things were changing. The French and British were disappearing, too, from the Michigan Territory, and the Americans had new trading policies that favored ruthless men like John Jacob Astor and his growing trading empire. Small-time traders hung on to what they knew best: leveraging their relationships with native tribes while looking for opportunities to make a buck with the Americans.

THE TRADER AT THE GRAND TRAVERSE

A case in point is that of independent trader, scoundrel, spy, treaty negotiator, cutthroat businessman, thief, friend to the Saginaw Chippewa and founder of the settlement of Flint Jacob Smith (1773–1825). Although opinions of him by his contemporaries vary, it appears that he always acted in his self-interest, which occasionally also helped the cause of others. He traded with the Saginaw Chippewa beginning around 1802 and was familiar with bands along Lake St. Clair, up the river to Lake Huron and to the Saginaw

Bay and its rivers. He took a Chippewa wife in 1805 and had a daughter with her in 1807, strengthening his family ties and trading status with her people. He traded widely with Indians at important village sites such as what later became Flint, Saginaw and Montrose, developing a wide sphere of influence. During the War of 1812, he worked with the Americans but was able to successfully negotiate with British allies Kishkawko and others at Saginaw for the release of a captive American family. After the war, he acted as intermediary between the American government and the Saginaw Chippewa, encouraging the Indians to sign the Treaty of Springwells to end hostilities. Later, he was contracted by Lewis Cass to assist with arrangements for the 1819 Treaty of Saginaw.

These various transactions were all to his benefit; if he had a side in the treaty talks, it seems to have been his own. At the Treaty of Saginaw in 1819, for example, he worked out a secret deal with Kishkawko that saved the treaty (but took millions of acres of the Indians' ancestral lands away), and he faked some Indian children as his in order to get reservation lands for himself at the Flint River. He also helped deprive a rival trader, Louis Campau, from receiving instantaneous payment for Indian debt. His apparent objective: as long as the Indians kept their silver, he had a chance to get their trade.[106]

Yet he was beloved by the band of Indians he traded most closely with at the place where the Saginaw Trail crossed the Flint River, called the Grand Traverse. Their chief, Neome, was very partial to Smith, and Smith, known by the Indians as *Wahbesins* (Young Swan), may have had warm feelings toward him and his band, too. Almost immediately after the Saginaw Treaty was concluded, Smith was setting up shop as a trader on the parcel of land he arranged for himself in the treaty. It was carefully chosen to enhance his business prospects.

On the north side of the river at the Grand Traverse was an important site Indians had used for perhaps a century to raise maize and other crops. It was a large area of rich soil called *Muscatawing* (the Open Plain Burned Over), for the native method of using annual fires to maintain fertility and aid cultivation. The Saginaw Chippewa frequented the Grand Traverse in large numbers every year to plant and harvest, and Chief Neome's sizable village was a few miles north along the Saginaw Trail. It was a good place to trade.

Jacob Smith was disliked and distrusted by most other traders and many of the businessmen in Detroit. He tried to wriggle out of debts, undercut the competition and was in and out of court for years. At one point, Smith was accused of having stolen goods from the post of a trader at Saginaw

but was acquitted of the charge. He remained at his cabin homestead at the Grand Traverse on the Flint River most of his final years, more trader than settler, as he only did minimal farming. If he meant to be the only white trader there, he apparently got his wish. There were only Indians for miles around, and he lived alone, with only a young native man to help him. He seems to have fallen on hard times soon after building the post but continued to do a certain amount of business, periodically taking goods to and from Pontiac. While there in the winter of 1824–25, he told a friend that he did not have long to live and that he wanted to "sleep his last sleep in the quiet neighborhood" of his cabin at the Flint River. When Smith died the next spring after a long illness, he was grieved only by Chief Neome and a few members of his band, who remained faithful in friendship to the last. His cabin was abandoned but stood for many years, a harbinger of the wave of white settlers soon to come. It was still standing in the late nineteenth century until it was engulfed by the city of Flint.[107]

A New Generation of Trader

The first generation of traders who married into the tribe and lived the Indian lifestyle gave way to a new generation when the Americans came. Like those before them, they also needed to understand two cultures to succeed, but now it was the Anishnaabeg on one hand and the American settlers who would displace them on the other. The future was not in long-term continuation of the fur trade but in how to take advantage of its last days while positioning for commercial opportunities of coming white settlement. The four sons of Oliver Williams were ready, willing and well suited to the task.

Alfred and B.O. (Benjamin) Williams and their brothers Ephraim and Gardner helped their parents establish their snug home at Silver Lake in Oakland County but soon were off to make their own fortunes in the open wilderness farther north. In 1831, Alfred and B.O. struck a course for the Shiawassee Valley and the trade potential there, while Ephraim and Gardner went to Saginaw. As young men, Alfred and B.O. felt at home in the forest with the indigenous people, the privations and the wild animals. As Pontiac, Birmingham and Royal Oak were facing the challenges of growing communities, the Williams brothers were in the forest, building

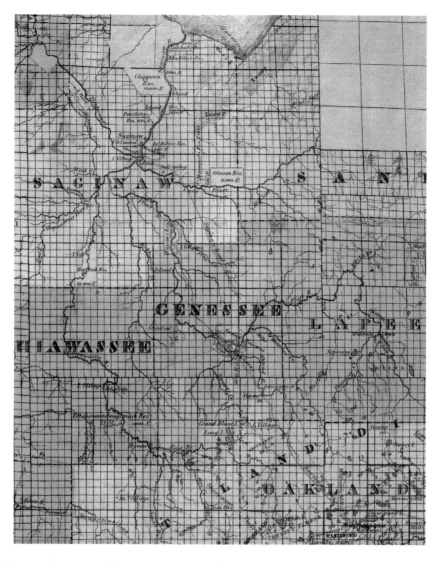

Between Pontiac and Flint, travelers left the Clinton River watershed behind and entered the Saginaw Valley, whose ecosystem supported the fur trade as late as the 1830s. *David Rumsey Historical Maps.*

on the tradition of first-generation traders like Jacob Smith. The important difference was they also had settlement in their sights. They realized they needed to go backward to go forward, relying on tradition to meet the Saginaw Chippewa where they were but planning for a future without them.[108]

The brothers had learned from their father, who handled conflict with Kishkawko so well that the Williams family was accepted as part of the tribe. They understood and showed respect for native culture and spoke a variety of Anishnaabe dialects. They were widely trusted by Indians as well as settlers and acted as arbiters when there was misunderstanding between the two. They were the first purchasers of land in the Shiawassee Valley with the intent to settle, founding the Shiawassee Exchange in 1831 on their land, which was really a trading post and general store that served local tribes as well as settlers. They were shrewd enough to locate near one of the largest reservations created by the Saginaw Treaty in 1819, *Kechewaundogining*, or Big Salt Lick.

The Shiawassee Exchange became the center of trade for the river country and the north, overshadowing even the older Campau trading post of Saginaw. In 1832, they sold their business interest to and became contractors for John Jacob Astor's American Fur Trade Company. Meanwhile, they got to know the local landscape and the settlers moving in and began planning for future investment. In 1833, they purchased two hundred acres with rapids for a mill and a good town site that would be called Owosso (for local Chief Wasso). Their timing was fortuitous. Within a year, cholera had struck the Indian population in the Shiawassee Valley, soon to be followed by even more devastating smallpox; the depressed fur trade never recovered. The Williams brothers increasingly turned their attention toward the new town and its growth. They built mills and devised a clever means of getting local wheat to market by floating flat-bottomed boats down the shallow Shiawassee to Saginaw. Within a few more years, railroads were crossing the former wilderness, making water transport obsolete. By the time of the bank and land speculation–driven Panic of 1837, there were few Indians and no fur market, so they closed the exchange for good.[109]

Alfred and B.O. had come to know the local Saginaw Chippewa bands and their traditions better than any other whites. In later life, they tried to record what they knew, although by then the Indians they traded with, lived near and advised were only faded memories. The local Shiawassee and Saginaw Indians who escaped the ravages of disease had been relocated to the Isabella Reservation at Mount Pleasant by the mid-nineteenth century.[110]

FROM PRIMITIVE TO PROGRESS

In 1830, five years after Jacob Smith's death, John Todd (a young man from Pontiac who had known Smith) built a cabin on the south side of the Grand Traverse of the Flint River in a tall stand of white pine. It was on the simple footpath that led south to Pontiac and north across the river to Saginaw. There he opened a trading post and inn of sorts and operated a ferry for travelers crossing the river to continue the Saginaw Trail. His wife, Polly, made meals and made wayfarers feel welcome at what became known as Todd's Tavern. In 1831, when Alexis de Tocqueville passed by on the trail, it was still utter wilderness; he was startled to find that Todd had a bear chained outside the cabin to guard it. Thus, even as late as the 1830s, when towns farther south on the Saginaw Trail had sprouted, grown, platted and improved their villages, the Grand Traverse of the Flint River remained as primitive as it had been a century before. But all this changed rapidly in a few years. The quiet outpost soon became a booming settlement and transportation hub and beacon of progress and industry known simply as Flint. By 1834, a successful sawmill was operating; by 1835, a turnpike road had been completed the forty miles or so from Pontiac to five miles north of the river, and Flint had been designated the seat of justice for newly formed Genesee County. In 1836, a land office opened to manage the high demand for public land sales at the Grand Traverse and along the many trails that radiated from there.[111]

It was no coincidence that the establishment and growth of Flint was due to the second generation of entrepreneur settlers and businessmen who emerged from the southern Saginaw Trail. Some, like John Hamilton, brought their means and resources from one community (in Hamilton's case, Birmingham) to start again in Flint. Hamilton began with only a sawmill at Flint but by his death decades later had broad business interests. His son William became a successful lumber baron until all the trees in the area were gone and he moved on to other local commercial endeavors. Others, like Rufus and Sherman Stevens, worked together to advance the towns of both Flint and Royal Oak. Rufus settled in Flint early on, building a profitable sawmill before investing in other interests. Sherman was crucial to bringing the railroad along the route of the Saginaw Trail to connect its growing communities, having traded a sawmill site in Flint for Hamilton's railroad right-of-way in Birmingham. Detroit, Royal Oak, Birmingham, Pontiac, Holly, Grand Blanc and Flint all got closer together as the railroad minimized barriers to transportation. The interior's natural resources, such as lumber, moved south by rail to markets in Oakland and Wayne

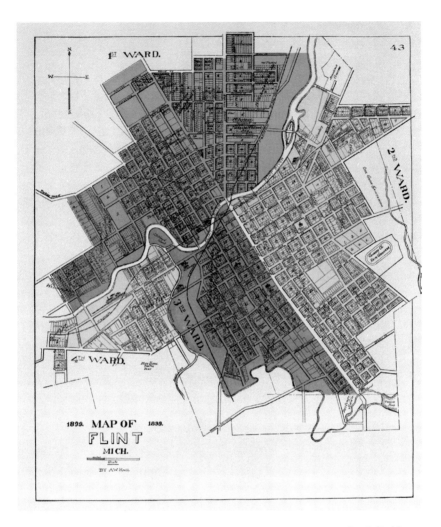

The city of Flint grew around the original fur trading post established by Jacob Smith not far from the crossing of the Saginaw Trail at the Grand Traverse of the Flint River. *Library of Congress.*

Counties, while people and goods in the growing economy of the Saginaw Trail corridor came north to Flint and strengthened their commercial and cultural ties. This was the same trading equation that had always operated; natural resources from the land went out in exchange for finished products coming in. In the decades to come, Flint would continue to be an important transportation center for points farther north, especially Saginaw, the ancient—and the modern—destination of the Saginaw Trail.[112]

Chapter 9
AT THE CROSSROADS

It brought the hunters with bear meat or venison, the women and children with berries from the forest. It brought runners with messages and scouting parties with reports on white men's encroachment. It brought the French trader with his ponies and Métis families in tow. Now it brought the *chimookamun* governor and his men on horseback, single file, for treaty talks in the late summer of 1819. The trail that connected the Saginaw Chippewa here with the Americans at the other end was called the Saginaw Trail.[113]

It was peacetime, but Lewis Cass and his soldiers were intent on displaying the might and force of the U.S. government and the "Father," the president. While Cass had hopes for concluding a treaty that would cede all the land around them and more to the United States, he was not in a strong negotiating position, and he and his men were outnumbered by the fierce and powerful Saginaw Chippewa in the heart of their territory. Just four summers earlier, the tribe had been the sworn enemy of Americans and only reluctantly signed the peace treaty at Springwells after the War of 1812. Experience had taught Cass that strength of character and fearlessness would make an important impression, so, mounted at the head of his entourage of advisors and interpreters, he emanated confidence.[114]

Cass had hedged his bets and prepared for this day for months, but he was far from confident. Advance parties of men led by traders the Saginaw Chippewa and local Ottawa (Odawa) knew well and respected had come to the Saginaw council ground to prepare by building a large covered platform with seating for the chiefs and open sides so the rest of the people could look

The Saginaw Treaty would mean the loss of the Saginaw Chippewa homelands, but the tribe was doomed one way or the other to starvation, and the deal would provide income that might help them somehow survive. *New York Public Library.*

on. This place was well chosen, as Saginaw was where the tribes traditionally gathered for council. They called it *Kah-bay-shay-way-ning* (or *Kepayshowink*), the great camping ground of their traditional homeland.[115]

A company of U.S. troops had come upriver and was on hand as well. The swelling numbers of men, women and children (estimates from two thousand to four thousand) who gathered for the council could overwhelm them at a moment's notice, though it was unlikely, since it was not in their interests to start another war. Cass had information from some traders who were close with the Saginaw Chippewa that suggested they might be agreeable to ceding more land. As dependent as they were on the fur trade, the disruption during the War of 1812 had taken its toll, depriving them of many necessities and causing great hardship, which put some chiefs in a mood to negotiate. On his end, Lewis Cass saw government funds spent on treaties as infinitely better than the greater cost of troops and war on the American population. He came prepared with silver that he had to borrow personally so he would not go to the talks empty-handed.[116]

THE HOMELAND

The Saginaw Valley could support a relatively large population, but the native peoples maintained a healthy balance of resources by selective hunting and fishing practices to avoid resource depletion. In addition to wildlife such as

elk, deer, rabbits, wildfowl and fish, the valley provided berries, honey, wild potatoes and the very important maple sugar and wild rice that were dietary and cultural staples. Ample prairies and oak openings were maintained by the native people for cultivating crops, especially maize, beans, squash and melon. Extensive systems of rivers allowed canoe travel, and a well-trodden network of major and minor trails fanned out from Saginaw in every direction, linking it to waterways and the interior and with easy access to the Great Lakes. The area had such a wealth of resources that, according to tradition, the Saginaw Chippewa had seized it for themselves from the Sauk people generations earlier, in a calculated massacre that exterminated the Sauk almost to a person. A deeply held belief by many of the tribe was that spirits of the Sauk still haunted parts of the forest, seeking revenge. Some have argued that the origin of the name Saginaw is "land of the Sauk," although others say it more correctly means "at the mouth (of the river)," which characterizes the valley well.[117]

The odds were therefore against Cass acquiring this land by treaty, as it was of such central importance to the tribe. But it was also a threat to white settlement, as it was capable of supporting large numbers of Indians, who could emerge once again as warring enemies. It had been only four short years since hostilities had ended with the British, and there were still fears of another invasion from Canada. The view of Native Americans as a foreign presence was reinforced by the notion that they were the conquered people of a foreign nation and not entitled to the same rights as U.S. citizens. Cass's focus was that of the federal government: get the Indians to leave and relocate west of the Mississippi, opening their lands for sale to waiting settlers while eliminating chances of hostilities.[118]

BARGAINING WITH THE DEVIL

By the time he headed back down the trail eleven days later, Cass was elated. The 114 Chippewa and Ottawa chiefs of the Saginaw Chippewa had agreed to terms, and aside from some sections of lands that created reservations at village sites along various important river areas, another 4.3 million acres of Indian title would now be extinguished. The U.S. government needed only to survey the land before selling it to Americans ready and willing to move in. The talks had been dicey, and the belligerent

Kishkawko was completely opposed at the beginning, as were some other chiefs. Somehow, Kishkawko was given a great deal of whiskey after that and, being completely intoxicated, was absent at the final treaty talks. His influence suddenly gone, and other deals and pressures brought to bear, the remaining chiefs assented. Kishkawko appeared at the signing and affixed his mark without comment.[119]

Whether it was lack of awareness of what the treaty really said; naïve belief that the reservation lands would be enough to support them; trust in traders and interpreters whose motives were not in the interest of the tribes but in their own benefit; desperation to gain annual payments for ongoing survival; or just a sense that it was useless to resist the American determination to have their land, the land they had stolen from the Sauks was, in effect, stolen from them. A poignant speech by young Ogemakekeketo (Chief Speaker) from a band on the Tittabawassee River suggests that he, at least, could see and was resigned to the inevitable:

Your people trespass upon our hunting grounds. You flock to our shores. Our waters grow warm. Our land melts like a cake of ice. Our possessions grow smaller and smaller. The warm wave of the white man rolls in upon us and melts us away. Our women reproach us. Our children want homes. Shall we sell from under them the spot where they spread their blankets?[120]

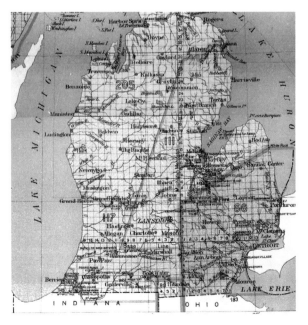

The Saginaw Treaty resulted in approximately a third of lower Michigan (middle section on map at left) being ceded to the United States, comprising the traditional rich hunting and fishing grounds of the Saginaw Chippewa. *Wikimedia image of 1895 Royce Map, Bureau of American Ethnology.*

At the Isabella Reservation in northern Michigan, young people were pressured to abandon traditional ways and learn a trade to adapt to white culture. *Clarke Historical Library.*

These words were eerily predictive. It was eleven days of talks in which the tribe's position was worn away to a mere shred of where it had begun. The Saginaw Treaty was a turning point that was followed by disasters that hit the tribe with such force that, in less than a generation, their numbers had dwindled from thousands to hundreds. First cholera came, striking suddenly and turning healthy people to corpses in a matter of hours. Then, smallpox came, wiping out entire families and bands in drawn-out suffering and anguish, scattering the remaining people. Impoverished and homeless, many were reduced to begging for food at the doors of white settlers. More treaties followed, taking away most of the remaining reservation lands that the Saginaw Treaty had provided. By the middle of the nineteenth century, the remaining Saginaw Chippewa, Black River and Swan Creek bands had been moved to the Isabella Reservation in mid-central Michigan. There, they were faced with educational policies, federal mismanagement and corrupt land practices that presented almost insurmountable challenges to their cultural survival by swindling them out of valuable land and trying to eliminate traditional language, dress and customs in the name of adaptation. In spite of this, the tribe was able to preserve its language and traditions, which have continued to the present day.[121]

Some native people found ways to adapt to the white culture all around them, making a living as they could in rural areas away from the tribe,

while others went to the cities to find jobs as American industry began to boom. Many who remained in Michigan found work, ironically, in the very industries that were depleting resources in their ancestral homelands, especially lumbering and fishing.

THE AMERICAN TAKE

After the Treaty of Saginaw, there was no going back. The choice had been made, the document duly signed and the spigot opened. Americans would hurry to the well and drink their fill of the Saginaw Valley unchecked. Before long, its natural resources would be harvested in the economic interests of production, growth and wealth for wealth's sake. The Saginaw Trail would soon become a wide road that would lead industry and inventiveness straight to the valley. The vast forests would be converted to board lumber to build the American West, the fish would be packed in barrels and sent hundreds of miles to feed growing cities, the wildlife would retreat and the wild rice shallows would be drained for large-scale agriculture.

Even though the treaty was signed, the government became concerned about a renewed threat from the still numerous Saginaw Chippewa. In 1822, the soldiers were back at Saginaw, building a fort at the great camping ground. By then, the Saginaw Road had been cut all the way from Pontiac, and the Americans made their intrusive presence felt. Kishkawko, who had received a reservation of land nearby in the treaty, tormented the troops at night. He made mocking threats and called out bone-chilling war whoops in the darkness, fueling the fort's fear of an imminent Indian attack. But the real threat to the Americans was the tormenting clouds of mosquitoes that interfered with every aspect of daily life. The floods had been worse than usual in the spring of 1823, and the mosquito infestation was so intense that a deadly malaria outbreak devastated the fort in the summer of 1823. Even the doctor was ill and unable to care for the sick and dying, which included the commanding officer's wife and children. The captain appealed for help, and the official response amounted to this: a fort was no longer needed at Saginaw. After the effort and expense of cutting through the road, building and supplying the fort and the lost lives of soldiers and civilians, the fort was closed less than a year after it was built. Settlement in the greater Saginaw Valley was checked, in fear of the Saginaw Chippewa, worry about disease

and Saginaw's remoteness. Settlers were discouraged by the setback, and some cut bait and simply left.[122]

But with the promise of good farmland, mill sites and investment schemes, the population began to grow again in the later 1820s. The wetlands were crossed at first by wading and soon by corduroy roads and causeways, which were in time replaced by plank roads. Bridges were built at key crossing points on the Flint River and other streams to open access to the north, even though seasonal flooding was such a hazard that they were sometimes washed away.

The attitude of the business entrepreneur and land speculator was little affected: we'll take the risk while the land is cheap. Settlers are bound to come, and we will make our fortunes. As statehood became imminent in the mid-1830s, a real estate and banking bubble in the form of wildcat banking and land speculation was spreading throughout the territory even as it was preparing to make the leap to statehood. Spiraling land values and the proliferation of investment schemes were taking the territorial economy to the bursting point. When it gave way, the Panic of 1837 had the effect of a widespread natural disaster in the new state. Successful businesses went under, public infrastructure projects came to a halt and credit dried up. Michigan's economy was stalled, keeping the lands of the Saginaw watershed wild for a while longer. But the inevitable was surely coming. Those who yet hoped to benefit had to find patience, while those who stood to lose everything, like the Saginaw Chippewa, dreaded the change the white man so eagerly awaited.

The Story of David Shoppenagon (1808–1911)

He was known as David Shoppenagon (or Shopnegons) (Little Needle) or simply as "Old Shop" by the whites near Grayling, Michigan, in the 1870s and later. He was a Saginaw Chippewa whose father was said to be a chief who fought with Tecumseh, receiving British medals for doing so, which Shoppenagon wore on occasion. He and his wife and children remained in the Saginaw area for many years, living by hunting and fishing. After 1872, they relocated to Grayling, where Shoppenagon supported his family through his woodcraft and hunting skill, becoming locally known and sought after as a guide for recreational sportsmen.

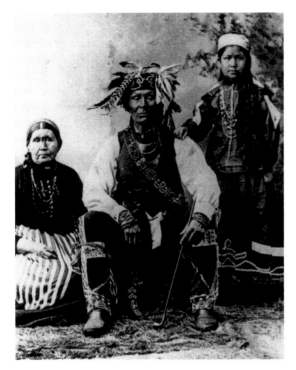

Left: David Shoppenagon and his family were Saginaw Chippewa who rejected reservation life to make a living independent of the tribe in northern Michigan. *Clarke Historical Library*.

Below: David Shoppenagon assimilated into the white culture of Grayling by acting as a hunting and fishing guide for out-of-town sportsmen. *University of Michigan, Bentley Historical Library*.

Shoppenagon rejected Indian life on the reservation, paradoxically retaining his autonomy by adapting to stereotypical expectations of whites. He often dressed in traditional regalia as part of the persona of a "good Indian," impressing the white sportsmen and hunting clubs that came to northern Michigan. This increased his popularity and helped him achieve economic independence. Shoppenagon let them call him "chief," though he himself did not use the term. But recognizing the market value in his name, he loaned it for promotional purposes to a local lumber baron in Grayling, as well as a tourist inn. This built his reputation even outside Michigan; he was the frequent guest of wealthy patrons in New York City. But above all, David Shoppenagon is credited with bringing attention to the great natural resources of northern Michigan, laying the foundation for today's successful conservation efforts. His life stands as an example of his determination to retain his dignity and independence while at the same time finding a creative way to adapt to white society. This made it possible for him and his family to live within, not apart from, white culture and earn the friendship and respect of the people in his community.[123]

PART II
The Wheel of Fortune

The facts are as certain as if they had already occurred. In but few years these impenetrable forests will have fallen. The noise of civilisation and of industry will break the silence of the Saginaw. Its echo will be silent. Embankments will imprison its sides, and its waters, which today flow unknown and quiet through nameless wilds, will be thrown back in their flow by the prows of ships.

...It is this consciousness of destruction, this arrière-pensée of quick and inevitable change, that gives, we feel...such a touching beauty to the solitudes of America. One sees them with a melancholy pleasure; one is in some sort of a hurry to admire them. Thoughts of the savage, natural grandeur that is going to come to an end become mingled with splendid anticipations of the triumphant march of civilisation.[124]

—*Alexis de Tocqueville, "A Fortnight in the Wilds,"* Journey to America, *1831*

Chapter 10
RIPE FOR THE TAKING

As Michigan approached the middle of the nineteenth century, it entered a period of growth that spread outward from the cities and inward to the interior along major transportation routes. The coming of the railroad followed the same course; first, to the most populous areas, generally following the early roads, and then stretching across the still largely unexplored frontier to other regions. Laying a railroad involved surveys, engineering and land right-of-ways, but once all was in order, construction took the straightest, most level route, often across open wilderness. Landowners and investors snapped up property along the route and also at planned rail stations. Settlements grew up around stops, especially where natural resources were located that could be retrieved, prepared and shipped by rail. A network of minor surface roads then fanned out from rail stations and towns.

In addition, there were the tried and true water routes that could be used during the navigation season. Rivers were the first highways in the Michigan wilderness and, before settlement, were used in combination with land routes by native peoples to travel between village sites and natural resources, such as good farming areas and maple sugar bushes. The Saginaw Chippewa used portages between waterways to create an efficient system to move through heavily forested land. The earliest pioneers used these same routes, and as towns grew along the river, river commerce grew and, with it, new ways of navigating the waters and making shipping profitable. When railroads connected to the river towns of Saginaw and Flint, commerce was extended to include the entire Great Lakes and the interior of the Saginaw

Valley. This created access to new markets and new demand, and the growth of the valley's industries experienced a rapid change in the latter half of the nineteenth centuries. By the early twentieth century, this made Saginaw the shipping center of the Great Lakes for a time.[125]

EXPLORATION FOR EXPLOITATION

In the early nineteenth century, settlement in the Saginaw watershed had proceeded slowly, mostly due to the economic setbacks of the Panic of 1837 and the area's remoteness. The wealth of the nearby natural resources was still being discovered. As Indian lands in Michigan were successively acquired after the mid-nineteenth century, surveys ensued. Surveyors made extensive notes of key resources: soils, water, timber and minerals. Localized industries grew in response to nearby population growth and demand. These included brickworks, which required clay and lime; smithies and foundries for wrought iron and metals; and other manufactories. As settlements were founded, nearby timber was needed for building dwellings and barns. The physical landscape and availability of raw materials determined the rate of settlement growth, which, in

In the nineteenth century, the Rouge River near the Saginaw Trail was dammed to power a flour mill for the local cash crop of winter wheat. *Birmingham Museum.*

turn, depended on the available transportation. In the 1830s, for example, sawmills relied on river current. But as steam power became available, mills had an independent power source that required fuel, usually wood. To receive and distribute their finished product, they were still located along rivers for transportation purposes. Meanwhile, water-powered mills found new life as flour mills for local wheat and other grain.[126]

The first settlers saw trees as obstacles to farming. They labored to cut, burn and clear them out of the way. White pine, however, was found useful for road building; in 1850, for example, demand for road planking spurred the founding of at least one sawmill in Saginaw strictly to build a road from there to Flint. The most accessible timber was harvested first. In Flint, the Fourth Ward's virgin pine stand marveled at by the first travelers was soon gone. Plank roads were started and then stopped as funding was available and then disappeared. It was expensive and difficult to provide the manpower and sawn planking out in the wilderness—that is, until sawmills were established.[127]

LUMBER BARRENS

The demand for white pine began to increase until it was the leading timber for U.S. markets, and it was abundant in Michigan. It grew tall in dense stands with few side branches, yielding sturdy, straight-grained wood that lent itself well to harvesting and processing. White pine was happy in wet and dry soils alike and thrived in areas of Oakland County and northward, becoming increasingly dense in the Saginaw watershed. Along the old Saginaw Trail route, one can still see the characteristic irregular tops of white pine protruding above woodlands in its original growth area as far south as Bloomfield Hills. But while today we might see these trees as majestic and symbolic of a wilderness past, they were viewed differently by settlers in the mid- to late nineteenth century.

As whites moved into the interior of Michigan, they encountered an expanse of ancient forest that extended as far as the eye could see. Before long, demand for sawn lumber began to climb for building materials throughout the United States. At the same time, transportation was making progress in the development of railroads and shipping. Advances in technology for harvesting timber and producing finished lumber likewise improved as

market pressure increased. In the wilderness of mid-Michigan, billions of board feet of lumber awaited harvest to supply the Victorian era's expansion and growth of the United States. Chief problems to be solved were in finding the timber, acquiring it through land purchase or other means, moving it efficiently to locations that had the power to saw it into finished product and having the means to ship the heavy material to Chicago and points west.

The sense that Michigan's forests were infinite—and could be harvested indefinitely—was commonly felt throughout Michigan, even as the giant trees thundered to the earth and greater swaths of land were laid bare. The profits to be had were head-spinning. Corrupt government officials made deals with rich and powerful lumber barons. Lumber companies sprang up throughout the Saginaw Valley and beyond, competing to acquire land cheaply and bring it to market for a handsome profit. Dozens of sawmills soon lined the banks of the Saginaw River to handle the massive amount of timber that poured into the area from inland forests. Year after year, lumber was cut and hauled in the wintertime to rivers that would carry it downstream to be processed. Year after year, crews had a harder time finding prime lumber and getting it out of the woods, having to go deeper and farther with less and less profit. Finally, the end of the lumbering era was at hand. When it was all over, Michigan's forests were gone, leaving behind a wasteland that for many years could support neither wildlife nor people.

Winter timber harvesting allowed heavy white pine loads to be sledged to the banks of frozen rivers until the spring thaw floated them downstream to waiting sawmills. *Castle Museum of Saginaw.*

There was enough timber to keep sawmills in business all along the river in Saginaw. Michigan lumber was sent by water to build Chicago and the western United States. *Library of Congress.*

People saw the forest timber of Michigan as an endless resource that would never be exhausted. *Detroit Historical Society.*

To complete the utter devastation of the landscape, extreme drought throughout the Midwest during the spring and summer of 1871, coupled with dry brush debris left by logging operations, resulted in conditions that only needed a spark and a wind to wipe out millions of acres of remaining forest. In October, huge forest tracts of Wisconsin and Michigan were engulfed in flames fanned by gale-force winds. Thousands of square miles were burned to cinders, resulting in great loss of life and property. The following year, a lumbering rush harvested the trees that were killed but not burned, and thereafter, the lumbering industry in Saginaw declined rapidly.[128]

GOING UNDERGROUND

As the lumber industry waned, the people of Saginaw turned to other natural resources in the valley. Advances in science and technology caught the interest of investors, who had hopes for riches from beneath the ground. In the Saginaw Valley, this included salt, coal and petroleum. Salt was an important commodity for food, livestock and, increasingly, fertilizer and chemical applications. It was located hundreds of feet below the surface, suspended in water, called brine, dating from Michigan's ancient past.

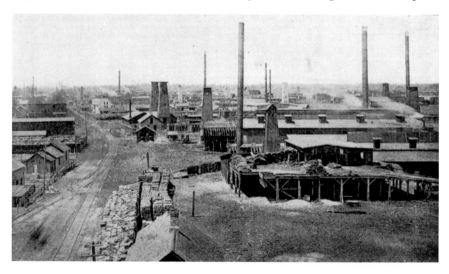

Salt was produced by pumping brine at salt springs and evaporating the water in large vats. Lumber mills had an ample supply of cheap firewood, so the two industries were often located together. *Butterfield,* Bay County, Past and Present *(Hathitrust).*

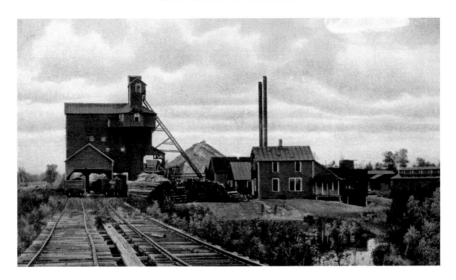

Coal was another natural resource in the Saginaw Valley that was produced for a short time before mines were abandoned as too expensive. *Castle Museum of Saginaw.*

Even before settlement, Indians and wildlife sought salt at springs in the area, and settlers were familiar with the salt seeps from an early date. To access the brine at these sites and other locations, wells were drilled and the brine was pumped into waiting vats in nearby buildings, called salt blocks, where processing took place. Salt was separated from other impurities and evaporated through heating. Locating near lumber mills allowed the use of scrap lumber for fuel, reducing costs and increasing profits. In their heyday, the salt and lumber industries dominated the waterfront on both sides of the Saginaw River.[129]

In the later nineteenth century, bituminous coal was known to exist deep below the surface in Saginaw and Flint. A number of shaft mines were built to extract it, but it soon proved difficult and costly to produce. As the need for fuel increased in the salt industry with the decline of the lumber industry, coal was used for a short time, but eventually all three industries weakened and died out toward the end of the nineteenth and early twentieth centuries. Similarly, initial attempts at producing a fourth natural resource, oil, were promising. But supplies were inadequate and costs too high to make it profitable on a large scale.[130]

As the twentieth century approached, it was the traditional resources that had been valuable to native people and the first settlers that became the economic foundation of the next hundred years: food production and its transportation.

Chapter 11
FROM FARM TO TABLE

he Native Americans knew it. And the first pioneers knew it. The
Saginaw watershed was rich in the one resource that was the ultimate
essential of life: food. People only had to care for the land's resources and
they would be rewarded. In Indian terms, cultivation meant burning the
prairie in the oak openings every year and planting crops that required
minimal work to bear, that grew well together and that could be stored for
use in winter. These crops were maize or corn, beans, squash and potatoes.
Orchards of apples and plums were also kept by the indigenous people.
Other foods grew naturally and would be harvested at the proper time, such
as maple sugar, berries and wild rice.

In white culture, agricultural practice was both more intensive and had
greater expectations. It was not enough to clear and till, plant and harvest
and store and save the fruits of the earth. To realize the full potential of
the land (and, as usually stated, God's will) required pushing it to its limits,
producing abundance and participating wholeheartedly in an agrarian
market economy. This required both a viable market and transportation.
The farther away the market, the faster the transportation had to be, and the
larger the market, the greater the volume to be produced. So as populations
grew and demand increased, the farmer had to maximize both.

As this area constituted the main land route extending out of Detroit
to the Saginaw Valley, the middle of the nineteenth century saw a great
deal of attention, activity and funding from individuals, businesses and the
government to help ensure that the farm-to-market loop remained robust.

Prosperity in Michigan was often marked by the economic shift from a simple sustenance-based family farmstead to a larger production farm. *Author collection.*

While there were initially good military reasons to cut roads through to Pontiac and then to Saginaw, it was the need for roads to move wheeled vehicles and cargo that was the main driver of ongoing infrastructure improvements. While lumber and other industries relied on water and to a

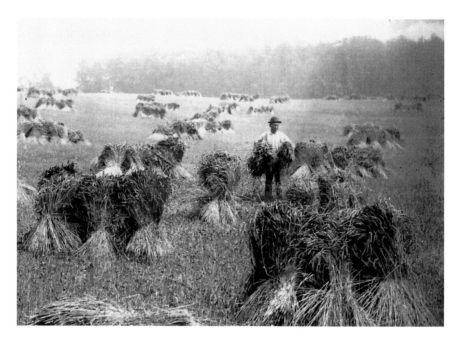

Wheat was a valuable cash crop grown in southeast Michigan and transported to market centers like Pontiac along the Saginaw Road corridor. *Oakland County Pioneer and Historical Society.*

lesser extent on rail, the farmer's first means of getting products to market was the road; the first farms were located near the Saginaw Trail or side routes that led to it. This became increasingly important as crop production increased and surface roads led to population centers. Later, after railroads were built, farmers needed local rail access to depots where produce could be loaded for shipping to further destinations.[131]

At first, local settlers or government troops built corduroy roads across swampy stretches of the Saginaw Trail, but it wasn't until the lumber industry's sawmills were able to provide planking that the Saginaw Turnpike came into its own. Plank roads were built to withstand heavy traffic over many seasons, were usually wide enough for large wagons and allowed farmers to plan the harvest and sale of crops at large city markets. Larger towns like Pontiac and Bay City became market centers where area farmers could sell their excess food crops and dairy products to middlemen who, in turn, shipped the products via rail or ship to waiting larger cities. But the progress in building the Saginaw Turnpike forty miles from Pontiac to Flint and then thirty miles to Saginaw was irregular. The economic depressions that followed the Panic of 1837 curtailed state spending on

roads. Private contracts were taken out to build sections of plank road, only some of which were completed. For a time, Michigan townships were expected to build and maintain roads in their locale, requiring residents to perform labor on the road as a form of tax. This system was ineffectual, as farmers ignored the requirement or did little work when they did show up to work on the road.[132]

The southern portion of the Saginaw Trail had greater population density and use and was closer to the Detroit market, and therefore, the turnpike's use and maintenance was more regular. For many years, privately built plank roads in Oakland County were maintained through fees collected at tollhouses, where an agent of the company lived and collected tolls at regular points. On the Saginaw Turnpike between Detroit and Pontiac, tollhouses were placed at one-mile intervals. However, it was a rare toll keeper who got up at 4:00 a.m. to collect user fees; instead, the honor system was practiced, and travelers deposited the required fees in a box provided for the purpose.

Tollhouses along rural plank roads often operated on the honor system; travelers heading to Detroit could toss coins in a box as they passed by in the early dawn hours. *Burton Historical Collection, Detroit Public Library.*

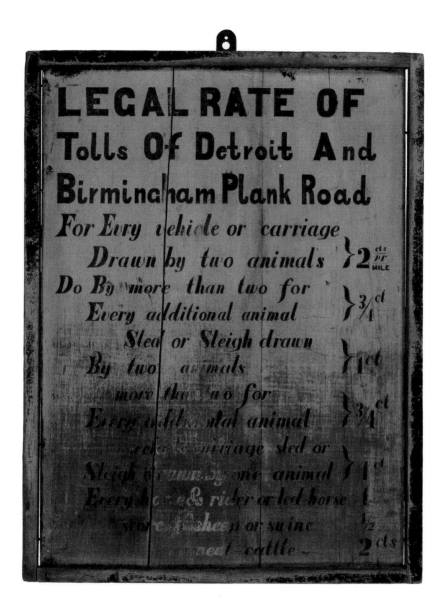

Plank roads were privately owned improved routes that allowed all-weather access to city markets by produce-laden wagons. Fees were usually collected at one-mile intervals. *From the Collections of The Henry Ford.*

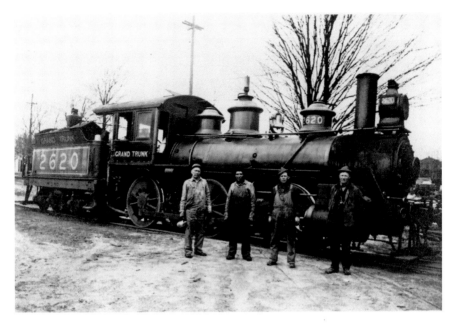

Railroads developed along the Saginaw Road corridor and quickly became an integral part of transporting products to market. *University of Michigan, Bentley Historical Library.*

Local Saginaw Valley farms needed to transport their crops, such as sugar beets, only as far as the nearby rail station, where they would be sent on to sugar plants for processing. *Wystan Stevens Image (Flickr).*

The later nineteenth century saw the establishment of agricultural economies around towns and larger cities to capture cash crops and funnel them to waiting city populations. Individual farms hired help but managed their own properties with an eye to supporting their families, bequeathing farm property to sons and selling excess produce for additional income. They were really small family businesses that were closely tied to the land and rooted in their local communities. Increasingly, family farms produced crops for agricultural industries as well as general consumption. They took advantage of the railroads that by then crisscrossed mid-Michigan, connecting local markets and farmers to the larger market centers. Farmers need only transport their crops as far as local train depots, and rail would take over from there. In the Saginaw area, for example, farmers could offload wagons of beets grown for the sugar industry at nearby rail stations in the morning and return home before midday.

Down to Earth

Pioneer farmers throughout the lowland areas eyed the rich soils of the marshes and wet prairies, but their periodic flooding was an obstacle. Settlers first dug ditches by hand to drain smaller sections of their lands all along the Saginaw Trail route from Oakland County north. This gave more arable land, and mosquitoes and snakes became less of a nuisance. Wildlife disappeared, too, but this was less important, as livestock could now be pastured more easily on more open lands. Local roads were easier to maintain and were built along section lines for easier access of wagons and plows. Where forest and swamps once dominated, now fenced farm fields dotted the landscape.

The march toward the industrial age in the late nineteenth century made it possible to apply new technologies to larger-scale drainage projects. Local landowners, investors and government officials banded together to drain what was seen as swampy wasteland into productive croplands. The demand was sufficient that in Bay City, a local industry grew up in the manufacture of special steam-powered dredging machines that mechanized the process, to the delight of investors and farmers and the occasional passerby. This was the epitome of control and domination of the earth.[133]

Such control was important for a farming experiment that took place near Saginaw that became an example of an early corporate agribusiness called the Prairie Farm. A large tract of almost thirty square miles of marshland prairie near Saginaw was under water much of the year, sometimes by several feet in the spring. To locals, it was "the worst and the best" land of the Saginaw Valley; being the lowest point, it constantly flooded, but it also had the benefit of thousands of years of rich alluvium deposits to offer.[134] Hartland Smith conceived an idea to purchase the land, considered "waste," with a group of investors, with the objective of draining it for farmland. Initially, three hundred to four hundred acres of marsh were drained by digging a long ditch to the Flint River, enclosing the area with dikes to keep floodwaters out. When that proved successful, additional acres were similarly drained. Approximately ten thousand acres of rich mucky soil was drained, becoming arable and productive farmland that was purchased in 1903 by the Owosso Sugar Company as an early example of a corporate farm.

Roads were built on top of the dikes for access, and the settlement of Alicia was built in the middle of the farm to support its inhabitants. During flood season, Alicia was cut off until the waters receded. Belgian horses were bred and used to plow the fields for most of the farm's productive period, and the majority of the arable acreage was used to raise sugar beets for sugar production. In 1917, Prairie Farm was said to be the largest farm in cultivation east of the Mississippi. However, after the stock market crash in 1929, the farm fell on hard times. It then briefly became a utopian communal farm community in the 1930s but failed, as its residents knew nothing about farming. The land was then purchased by the U.S. government for a farm community experiment but ultimately was sold off in parcels to individual farmers. Since the 1950s, approximately ten thousand acres of the unique wetlands have been returned to their natural state, as the Shiawassee National Wildlife Refuge.[135]

In the late nineteenth century, it became clear that the most valuable resource along the entire three-county Saginaw Trail corridor was the earth itself. The existence of the cursed swamps and marshes was likewise a measure of the agricultural quality of the alluvial deposits below. The Saginaw Valley, with its fertile ancient lake beds, has since captured the imaginations of small farmer and agribusiness alike. As a result, economic forces have shaped the area to maximize agricultural production. However, another, even more powerful economic driver has had greater lasting impact.

As the Saginaw Turnpike entered the twentieth century, the landscape around it changed quickly. The old road that had been used primarily for

To a small farmer, the motorized truck was a great improvement over the horse-drawn wagon for transporting products to market. *Calvin College Archives.*

wagon traffic between the sleepy towns along the way or for local residents visiting nearby communities in horse-drawn buggies took on a different character. It led far outside the nearby boundaries of the village and the people one knew and saw every day in town. It was a fundamental change in the human experience of the land and their place upon it. It had everything to do with technology, and it had everything to do with progress, but most importantly, it had everything to do with transportation and the Detroit end of the Saginaw Trail.

HELP WANTED

A s the economic base of Michigan developed, the Saginaw Trail area followed suit. In much of the Northwest Territory, the early settlement period moved from fur trade commerce into a primarily agricultural economy. For the first half of the nineteenth century, this was in the form of small-scale homestead farmers. They followed the agrarian model of the eastern United States, purchasing parcels of land, clearing and raising crops and livestock for their own subsistence. As soon as they could clear additional acreage, they planted cash crops to supplement their income, reinvesting in additional acreage if possible. Over the decades, larger farms began to dominate the landscape, knitted together by local roads that led to turnpikes and highways. Settlements became villages that were organized around localized market centers that allowed travel by wagon to and from town in about a day. The manufactories that existed were those needed within this local farm-based economic sphere such as smithies, foundries, brickworks and grist and sawmills.[136] Other businesses in small towns included mercantile concerns, printers and trades such as carpentry. Professions such as legal and medical practices also appeared in small towns. In low-density rural populations, it was common for residents to function in multiple roles; a homestead farmer could also be the local postmaster, a justice of the peace, a minister or a doctor.

UPWARDLY MOBILE

From the middle to the end of the nineteenth century, the American economy began to change as technology made large-scale manufacturing viable. Steam power replaced hand work, animal power and water power. Productivity and profitability climbed for high-demand industries in cities like Detroit, Pontiac, Flint and Saginaw, where ironworks, milling and lumbering became concentrated.[137] Larger operations used mechanization with greater efficiency, increasing size of factories, which, in turn, changed the face and the place of American labor. A dedicated workforce was needed in factory settings, meaning employment was increasingly outside and away from one's home. Housing patterns and transportation needs changed accordingly, as populations shifted from the countryside to cities, where daily travel might be needed to get to employment. Laborers were increasingly mobile, following the work wherever it took them as demands fluctuated. For many, owning land was no longer the means to economic survival. Rental and temporary housing became common. Workers were drawn from the United States and abroad to Michigan's lumber, railroad and other growth industries.

Agricultural production likewise was transformed. From the outset, Michigan farmers augmented their income with surplus and profitable cash crops for distant city markets. Pioneers raised corn to produce whiskey and apples for cider, as well as highly desirable wheat, making accessibility to a nearby gristmill an important driver of local economy and settlement. Lands that could support a good wheat crop were the most sought after, and in the nineteenth century, Michigan became a major U.S. producer of winter wheat. Another ready cash crop during the period was wool; in the 1870s, Pontiac became a major market center for Oakland County's wool production, as well as for corn, potatoes, wheat and other grains, pork and cheese. With the advent of mechanization, farms became larger and more industrialized, utilized scientific practices and were able to realize greater profit through specializing in high-demand agricultural products.[138]

While the small farmer might hire labor during harvest to bring the crops in, most farm labor was performed by the farmer-owner and his family, in the way of a small business. But as farms grew in scale, a larger labor force was needed, although the nature of agriculture kept that force seasonal. With the growth of cities and industry in the late nineteenth and early twentieth centuries, people began to leave farms for urban settings, increasing the farm labor shortage. As early as the 1920s, the farm labor needed in Michigan had to be imported on a regular basis, leading to dependence on migrant

Investors saw the stands of Michigan's white pine as a way to make big profits on cheap timber lands. Lumberjacks saw just another day's hard work. *New York Public Library.*

The agricultural economy relied heavily on rail, and a labor force of rail workers was needed to keep the trains running and maintain the lines. *Royal Oak Historical Society.*

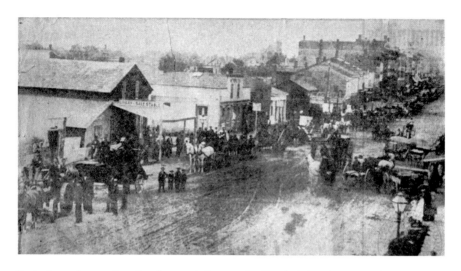

In the later nineteenth and early twentieth centuries, Pontiac's location on the Saginaw Road and its status as Oakland County seat created a thriving agricultural, commercial and manufacturing center. *City of Pontiac.*

Farming was a small business enterprise that depended largely on family labor. *Calvin College Archives.*

In the early twentieth century, lack of farm labor increased demand for migrant farm workers in Michigan. Children were often part of the family's labor force. *New York Public Library.*

agriculture workers. In the 1940s, migrant farm laborers came to Michigan from economically depressed areas such as Appalachia and Mexico to work for fruit growers, sugar beet farms and other agricultural producers large and small. Workers moved as families from harvest to harvest, taking their children with them. It was not uncommon for children as young as three and four years old to work in the fields and to receive little or no schooling as they aged into migratory life. Housing provided by farmers was substandard, and pay was exploitive.[139]

During World War II, the farm labor shortage intensified. In Michigan and elsewhere, German and Italian prisoners of war held in rural camps were used as day laborers on local farms and agricultural industries. In the Saginaw Valley, Camp Freeland (currently the site of MBS Airport near Saginaw) and Camp Owosso (built at Owosso Speedway just west of Flint) supplied low-paid POW labor for canning operations, sugar beet growers and other farms in the area.[140]

MANUFACTURING MELTING POT

Labor demands increased in manufacturing industries in large population centers, but workers similarly faced poor conditions, long hours and low wages. Low or unskilled labor made up the majority of the workforce in early industries like lumbering, sawmills, mining, and ironworks. Housing was often inadequate to support worker populations, especially at times of intense growth. For example, during the late 1910s and early 1920s, housing in Flint was overwhelmed by the influx of migrants seeking work in the early auto industry. Workers were housed in a shanty town near the auto plants for a time while houses were quickly built to accommodate them. The influx of workers meant there was also work for foreign-born immigrants and minorities who, along with women, were paid reduced wages for the same work of their white male counterparts, which was already low paid. The exploitation of the auto industry's labor force led to pressures to unionize to force automakers to improve conditions and pay. Organized labor finally was victorious after the revolutionary forty-four-day Flint Sit-Down Strike

In 1937, workers refused to leave General Motors plants during a history-making forty-four-day Sit-Down Strike. *Library of Congress.*

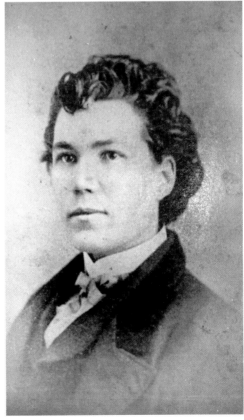

Above: Traditional work roles of women continued to emphasize the home; however, women were increasingly employed in clerical, educational, medical and sometimes industrial jobs. *Oakland County Pioneer and Historical Society.*

Right: During the Civil War, Sarah Edmonds cut her hair, changed her name to Franklin Thompson and enlisted in the Union army at Flint. When she was injured on the battlefield, the army surgeon kept her secret until the war was over. *Clarke Historical Library.*

137

The healthful countryside of Pontiac was an ideal location for the Eastern Asylum, built in 1878. Its immense size created a virtual city and a need for a large workforce made up predominantly of women. *Oakland County Pioneer and Historical Society.*

of 1937, when General Motors backed down and workers gained important rights through organizing.[141]

Women, however, had a much steeper hill to climb and more ground to cover. In the nineteenth century, they still were unable to vote, hold office, in many cases own or control property and may not even be taught to read and write. By mid-century, however, women's rights movements began to take hold, especially in New York and the East. Lack of access to education, voting and other legal rights were of central concern, as well as fair wages and access to many desirable occupations. Stories surfaced about women posing as men to work on ships, as cowboys or as soldiers, a testament to the desperation some women felt to achieve freedom of identity and self-sufficiency. But the vast majority of women's livelihoods remained restricted by socially determined roles and duties.

Women remained far behind men in workplace opportunities, even as late as the early twentieth century. It was unusual for women to work for wages, but by no means unheard of, especially in cities. The most acceptable way for married women to earn wages was through side work such as laundry or sewing, or on occasion, women helped a male family member operate a small business. Single women could find work associated with traditional

roles, such as maids, teachers and nurses. In larger cities, working women were just as much exploited in so-called traditional occupations; for example, the garment industry became notorious for locked sweat shops that required women and girls to work as long as twelve hours without a break. Even after earning the right to vote in 1920, women, like minorities and foreigners, continued to be paid less than the general workforce of white males for the same work. In some cases, hiring women to save money became a common practice in Michigan's auto industry, to the displeasure of many men, who they displaced.[142]

FOUR WHEELERS

As manufacturing became increasingly important to Michigan's growth, the Woodward-Saginaw highway corridor became a center of gravity for both the old agricultural and the new industrial economy. Important industries evolved at Detroit, Pontiac, Flint and Saginaw for the reasons they had always succeeded there: there was ready access to land and water transportation, to natural resources and to markets. Their physical proximity and social and cultural connections reinforced the development of support and supply industries that fortified their interdependence.

They also had direct access to the increasingly heavily traveled Woodward Avenue/Saginaw highway route, which widened with railroads linking the four cities that resulted in a major transportation corridor for quickly and cheaply moving products and people.

And all four cities were also well connected in other ways: they had a pool of wealthy investors made up of industry magnates who had made vast fortunes on lumber and mining and plenty of cash to back a new idea.[143] With the advantage of being the seats of their respective county governments for half a century or more, they also had the powerful economic force that had always been a boon: political influence. Quite naturally, when new technologies emerged in manufacturing or transportation and government incentives improved infrastructure investment, the Woodward-Saginaw corridor was the first to see the benefits.

With their proximity to this major transportation route, all four cities developed expertise in carriages and buggy manufacture. During the later part of the nineteenth century, the carriage industry had grown to support many competing companies in Detroit, Pontiac, Flint and Saginaw that shipped their products all over the United States. It was natural, then, that they developed specialized technological approaches to transportation. Experiments in motorizing carriages led to various applications of self-propelling engines, and the excitement of invention generated local motorcar companies in each city. It was the birth of the auto industry, and there were unique siblings in all four places.[144]

For example, in the first two decades of the twentieth century, a range of motorized vehicles was produced by small companies in Saginaw. One of the early successful designs was an electric car called the Argo, produced from 1910 to 1916, whose successful run was cut short as the internal combustion engine took precedence. Such small automakers were unable to survive, but Saginaw continued to play a major role in the industry through design and production of components. The most important of these was the Jacox steering mechanism of Jackson, Church and Wilcox that became Saginaw Steering Gear, a division of General Motors. Meanwhile, in Flint, the engineering genius of David Buick and Louis Chevrolet was hijacked by millionaire William Durant of Durant-Dorr Carriage Company to found General Motors, which made Flint the largest producer of autos in the early twentieth century. Before long, GM had acquired a number of early auto companies such as Oldsmobile and Cadillac, making General Motors an industry giant and major employer in the city of Flint thereafter. The city was so proud of its prominence in

Flint was the center of the carriage industry in the late nineteenth century and proudly named itself "Vehicle City" years before industry giant General Motors was founded there. *Burton Historical Collection, Detroit Public Library.*

the carriage industry that it called itself "Vehicle City," which pertained to its role in the coming auto industry as well. GM was also busy elsewhere in the Woodward-Saginaw corridor. In Pontiac, the successful Pontiac Buggy Company became the Oakland Motor Car Company in 1908, merging with cross-town fledgling automaker Pontiac Spring and Wagon Works before being bought by William Durant and incorporated into General Motors as the "Pontiac" brand. Meanwhile, the successful Pontiac company, truck maker Rapid Motor Vehicles, was likewise acquired by GM and joined with Reliance Truck (built in the Saginaw Valley at Owosso) to become the foundation for the GMC Truck brand. Thus, the Woodward-Saginaw corridor formed the nucleus of the burgeoning auto industry. But it was at the Detroit end of the corridor where everything came together perfectly. The infrastructure that had helped build the nineteenth-century iron-based industries of railroad cars, stoves and shipbuilding, in combination with access to transportation and expertise of the local carriage industry, positioned Detroit to dominate the global auto industry.[145]

BOOM AND BUST

The cyclical nature of the economic forces that ebbed and flowed in early Michigan revolved around local resource development and depletion, coupled with larger financial fluctuations and changes in technology, just as in most parts of the United States. However, Michigan experienced more extreme cycles in proportion to its great natural resources and explosive growth, resulting in just as sudden reverses. Lack of planning could also result in devastating losses from natural disasters, particularly flooding in the Saginaw Valley. Unanticipated consequences were sometimes not evident until long after an industry had become obsolete. Lumber, coal, salt, minerals,

industrial agriculture and especially auto manufacturing and supply were successful economically at the expense of the environment. Pollution of rivers and lakes, air and soil took its toll on wildlife as well as people, leaving big problems for a future solution that sometimes never came.

In the city of Saginaw, the great growth, cultural development, grand avenues and resort-like waterfront built during the lumber heyday in the nineteenth century were gradually replaced by the factory-dominated riverfront with freighters, mounds of coke and iron ore and other industrial development incompatible with resort life. For the city of Flint, periodic large-scale disaster has been a regular part of its history, often relating to its river. This has included catastrophic flooding in the past and widespread exposure to lead-contaminated water in the present day. Furthermore, the very auto industry that made Flint its home dragged it down to the depths of economic depression as GM took its production elsewhere and abandoned the city and its residents in the late twentieth century. Likewise, Pontiac, whose fortunes were similarly tied to the auto giant, suffered a similar fate.

This nineteenth-century map captures Saginaw's progress and pride in its lumber industry. In less than a generation, the forest was gone, and so was the wealth that built the city. *New York Public Library*.

Natural and man-made disasters have plagued Flint since its fur trading days. Tornadoes, floods and, more recently, lead-contaminated water have all taken their turn assaulting the city and its people. *Sloan*Longway, Flint, Michigan.*

The great Woodward Avenue was the main artery that connected Detroit with the rest of southeast Michigan. *Library of Congress.*

Its slashed tax base and reduced population are economic losses that have resisted recovery.

The city of Detroit, however, is the definitive symbol of loss and recovery. The cycle of devastation and rebirth has been visited upon the city many times over. Even as far back as the fire of 1805, its essence has manifested both tragedy and hope, looking backward and forward at once. In the late nineteenth century, Detroit was part of the City Beautiful movement and was considered the Paris of the Midwest. The great city of the early twentieth century that was the heart of the auto industry looked lifeless years later when it fell on hard times, and the great shopping and cultural district along Woodward Avenue became little more than an abandoned ghost town. Currently, the city is again undergoing a renewal of cultural and civic development, experiencing a new surge of economic activity and urban bounty. Once again, Woodward Avenue is an artery directing renewal and prosperity into the interior of Michigan.

Chapter 13
WAY TO GO

Transportation changes transformed the relationship of people to their immediate environment and each other, broadening their perception of their world. A homesteading farmer's need to travel might extend no farther than the nearest town, and a person might live one's whole life without ever seeing a big city. For many migrants in early Michigan, leaving one's relatives behind meant never seeing them again. Isolation was an expected part of pioneer farm life, so until the latter half of the nineteenth century, one's community and social identity were defined and limited by the distance one could ride a horse or walk.

Small wonder, then, that railroads were miraculous in the eyes of most of the American population; they allowed distant travel in affordable comfort, made it possible to send and receive large or heavy items even to rural destinations and were reliable even in winter. They opened a whole new world at the doorstep of the nearest train station; one's relatives back in New York were, amazingly, just a day or two away. The vast distances and speed with which trains could travel even changed how people measured time. Local time had always been determined by the location of the sun. But with the speed of rail travel, ground measurement of time was different than the passage of time on the train as one moved west or east. This resulted in confusion at best and collision at worst as railroad engineers had to coordinate their arrivals and departures based on sometimes inconsistent timing. In the 1880s, standard time zones were adopted to address the problem, which had never existed before.

Another change in transportation technology had an equally major impact on American life and in transforming its roads, but it came in the unlikely form of the self-propelled vehicle known as the bicycle. Initially, experimental three- and four-wheeled vehicles were produced that people could power themselves, but they were large, heavy and difficult to maneuver. By the late nineteenth century, a lighter, two-wheeled version evolved, requiring balance but being lighter and easier to control. Progressive improvements in engineering produced a model with a large front wheel and smaller rear wheel, a design that helped with efficient propulsion. This was called the velocipede or the "penny farthing" bicycle—fast but dangerous. Finally, in the 1890s, further design improvements created a rear-wheel chain drive bicycle with smaller wheels that was safer for both men and women, and the American love affair with the bicycle began. The enormous appeal of these personal vehicles created a need for better road surfaces, especially outside cities, resulting in the emergence of the Good Roads movement, an organized grass-roots effort to influence government to build improved road infrastructure. The movement was successful in raising awareness of the importance of roads and the need for government investment in them, and as the automobile came on the scene, it benefited from the inroads made by bicyclists.

FROM HORSE POWER TO HORSEPOWER

Horses had been the means of transportation for so long that they were a part of everyday life—the sights, sounds and smells of living animals populated streets, farmyards and country roads. Just as today we have incorporated automobiles into our lifestyles, our home design and our daily routine, so, too, the horse was part of ongoing human activity in nineteenth-century America. A living work animal required shelter, food and ongoing care each day to stay healthy. Carriages were the preferred mode of personal travel for most people in and between towns, and they likewise needed storage and maintenance, as did the wagons used for transporting goods and cargo. Horse-drawn vehicles could better tolerate poor or muddy roads, rough planked turnpikes and stony, uneven tracks. Therefore, in the early automobile era, the superior strength and traction of horses were commonly called upon to pull disabled motorcars

Horses were the go-to means of personal and small-scale conveyance in town and country. Liveries kept them in good working order, much like auto mechanics would do for cars in years to come. *Birmingham Museum.*

Rail provided personal long-distance transportation for business and recreation. Traditional buggies offered local taxi service in villages on the rail line, like Clarkston. *Oakland County Pioneer and Historical Society.*

out of muddy tracks. Thus, horses were trusty and reliable in a way that automobiles had not proven themselves to be. Horse-drawn vehicles continued in use, especially for heavy loads and farm products, into the 1920s. But as motorcars and trucks became more popular and reliable and roads improved, the use of workhorses dwindled. Interestingly, the southern Woodward corridor between Royal Oak and Detroit still showed active use of horse-drawn vehicles as late as 1925, although horse traffic was soon eclipsed by auto traffic on the route. Meanwhile, carriage barns built for suburban houses in the 1910s were soon refitted as automobile garages as one form of horse power gave way to another.[146]

Yet another form of transportation technology became popular in more densely populated areas: mass transit, electric-style. Known as interurban rail lines, they offered predictable schedules to local destinations for a reasonable cost and relative comfort. Electric railways sprouted up in urban areas in and between large cities, often building their electrified lines adjacent to railroad rights-of-way or, in cities, in the middle of the street. Unlike railroads, interurban rail lines were intended for shorter distances and ran more often, for instance, the Detroit United Railway (DUR) that operated several times a day between Detroit and Flint along the Woodward-Saginaw corridor. One didn't need to own and house an automobile; a short walk to Woodward

The interurban rail line ran alongside Woodward Avenue. It offered a modern alternative to horse-drawn transportation before the advent of automobiles, with conveniently located waiting shelters. *Royal Oak Historical Society.*

Local electric rail lines like Detroit United Railway (DUR) provided passenger service and commercial transportation between small towns and Detroit along the Woodward-Saginaw corridor, all the way to Flint. *Birmingham Museum.*

Avenue could transport a resident in Royal Oak to downtown Detroit, the resorts of northern Oakland County or for a visit with a relative in Flint. The era of electric mass transit was short-lived in southeast Michigan, however. Electric rail lines fell out of use as automobiles became more affordable and it became common for every household to have its own motorcar. By the early 1930s, the interurban electric rail lines had closed, and the rails were removed soon after.[147]

ENGINEERING THE TRAIL

No matter how impractical they could be, no matter how bad the roads were, no matter what the cost, automobiles captured the hearts of nearly everyone. Luxury models, sporting models, everyday basic models—all found a mass market in the American populace. They soon transformed not only Michigan's economy but also housing design and location, recreation

and street planning. They indelibly etched a consciousness of and desire for independent mobility and personal agency. People felt liberated. They could go where they wished, when they wished, and they were masters of their immediate destiny (even if that destiny was really just a nearby destination). In Detroit, an unrelenting demand for better roads brought the emerging science of highway engineering to the old Saginaw Road that began in Detroit as Woodward Avenue. In 1909, the heavily traveled portion of Woodward at the northern edge of Detroit between Six and Seven Mile Roads was paved in a new road material, concrete, making it the first paved concrete highway in America. By 1916, Woodward Avenue had been paved a full sixteen feet wide as a two-lane highway for the entire thirty-seven-mile route to Pontiac. Engineers dusted themselves off, congratulated one another on a job well done and walked away, for they had just improved the most important road in the country, and it was expected to last a generation. But they were soon back at the drawing board; the new road proved completely inadequate within just a few years. They had failed to account for the tremendous growth in population and automobile traffic that soon clogged Woodward, creating miles of backed-up vehicles as people came and left Detroit daily. It was the first real "rush hour." By 1921, local officials in Wayne and Oakland Counties were scratching their heads about what to do to alleviate the problem. Finally, the Detroit Automobile Club proposed a solution: widen Woodward Avenue between Detroit and Pontiac and create a multi-lane thoroughfare to handle the heaviest, most traveled route in America: "It is considered that the entire state is interested in Woodward Avenue as a highway from Detroit north. It is the state's heaviest traveled thoroughfare and occupies a position among the leading highways in the country....Traffic on Woodward avenue [sic] between Detroit and Pontiac has increased tenfold in eight years."[148]

Through state, county and local efforts, tax dollars were authorized and right-of-way acquired to widen Woodward as a "super-highway" to 204 feet, with a boulevard and room for interurban rail. By 1926, the stretch to Pontiac was nearly complete, except for a section in Birmingham that was being routed around its downtown. The super-highway stretched into the beautiful countryside, drawing people from the city to the fresh air of the country and the American dream of a suburban home:

When the widening of Woodward Avenue began many farms were being tilled along its distance between Pontiac and Birmingham and between Birmingham and Royal Oak. Today scarcely a farm remains along the

Although Woodward Avenue had the first concrete pavement in the nation, it still had unimproved sections that turned to deep mud after a rain. Difficult enough for wagons, these roads were almost impossible for automobiles. *Burton Collection, Bentley Historical Library.*

entire 13 miles. A great residence community has been built up and suburban homes now dot the landscape and bid fair within the next few years to build up both sides of the super-highway completely from Pontiac to Detroit....

....Thus there extends over the hills and through the valleys of the picturesque Oakland County scenery...the world's greatest pavement—running straight and beautiful as engineering skill could make it, in the very places where ten years ago a sixteen foot pavement was laid and thought ample for a generation; in the very places, too, where a century ago the frontiersman was making his painful way through the woods, and where the Indian had his hunting trail.[149]

The desire for more suburban homes near Woodward between Detroit and Pontiac invited engineers to apply man-made solutions to a natural problem that had been part of the landscape since the glaciers retreated: water. Specifically, the water that ran through the surface tributaries of

Paved roads with heavy traffic created congestion problems for small towns with streets that were designed for buggies and wagons. *Birmingham Museum.*

The density of traffic made Woodward Avenue one of the most heavily traveled routes in the United States. The solution: the first divided multilane (or "super") highway in the country—Wider Woodward. *Oakland County Pioneer and Historical Society.*

the Red Run Creek and routinely flooded along Woodward in Royal Oak; the water that there was just a little too much of and was not controlled sufficiently for modern taste; the water that nobody wanted to have in the way anymore. The solution: re-route the creek underground in a concrete tunnel-like conduit and channel it safely away from new development. Stone bridges that had been built over the creek were left in place and incorporated into a wide boulevard that can be seen today along Vinsetta Boulevard in Royal Oak, marking where the creek used to be visible at the surface. Nowadays, when basements flood during heavy rains, residents are reminded of the existence of the old floodplains around them.

Years later, the Clinton River faced a similar destiny. In 1964, the city was enamored with the concept of "urban renewal." This led it to believe that creating a fast-moving multi-lane loop of traffic around Pontiac's downtown would serve the city well and help it grow. It didn't; people bypassed the city altogether. As part of that ill-fated plan, the Clinton River, which had wound through the landscape for millennia, had to go underground. An enormous engineering project ensued, creating a below-ground channel that took the river out of sight—and out of mind. The river is no longer visible

Modern engineering diverted Red Run Creek underground to develop valuable land along Woodward in Royal Oak. The "ghost" of the riverbed can be seen along Vinsetta Boulevard. *Royal Oak Historical Society.*

During Pontiac's "urban renewal," the Clinton River was channeled under the city. Woodward Avenue was expanded and renamed Wide Track (after the Pontiac automobile) for the road's loop around the city and back to Detroit. *Barbara L. Frye Collection.*

in Pontiac and has been built over with streets and buildings. It reemerges east of the city and continues on its way to Rochester, Mount Clemens and Lake St. Clair. Present-day city officials, planners and citizens alike mourn the loss of the river. Any advantage the natural river's course may have offered to beautify and revitalize Pontiac's downtown character would now be impossibly expensive to reconstruct.

An engineering challenge of another kind emerged at the northern end of the Woodward-Saginaw corridor in the 1980s. In 1960, interstate highway I-75 had been built along the old Saginaw Trail route through lower Michigan. A drawbridge was built across the Saginaw River at Zilwaukee just north of Saginaw to allow necessary freighter traffic upriver with industrial ore and other material. The relatively low banks of the wide Saginaw River and the regular freighter traffic meant frequent interruptions of vehicular traffic. During heavily traveled periods, travelers dreaded the approach to the bridge, where passing river traffic could hold up vehicle traffic for miles in both directions. The need for a better design was immediately apparent but took decades to accomplish. The great Saginaw River, the largest river system in lower Michigan, was not only wide but also surrounded by marshy

Where I-75 crossed the Saginaw River on the old Saginaw Trail route, river traffic took precedence over autos, creating legendary backups at the Zilwaukee drawbridge. *Detroit Historical Society.*

floodplains. The final redesign of the Zilwaukee bridge was completed in 1988, is one and a half miles in length and provides a 125-foot clearance for river traffic. From the top of the bridge, auto travelers peering over the side can see the wide, green expanse of the Saginaw River Valley. Except for the piles of ore and buildings in the distance, it is possible to gain an appreciation for the greatness of this still valuable resource and a sense of its original grandeur.[150]

ARE WE THERE YET?

Michigan yielded its natural resources to the axe and the saw, the drill bit and the well, and in the process lifted a whole new group of Americans into a lifestyle that offered disposable income and time for recreation. For the first time, large portions of the population could afford some of the finer things in life, look out over Michigan's wilderness and waterfronts and flock to its beaches and resort destinations, such as Mackinac Island. Travel for recreation became part of summertime for many Americans and, as wages increased, for unskilled laborers as well. Even if their daily work involved depleting natural resources, there was a widespread appreciation for the beauty of nature and the desire to be close to it.

HOUSEBOATS AND RIVER PEOPLE

The Saginaw River Valley was large, wild and green, and in the lumbering era, the city of Saginaw had wide streets with large well-appointed homes and electric streetcars. It boasted cultural jewels like a fine library and art museum and was graced by a natural riverfront. The slow-moving river was deep and wide; levels varied throughout the year with regular flooding. During the lumbering era, rafters used practical floating shelters for supplies. After the lumber boom, the idea of rafted shelters evolved into houseboat

In Saginaw, a recreational houseboat culture developed in the late nineteenth century that became substandard and unsanitary habitation for impoverished "river people" in the industrial early twentieth century. *Castle Museum of Saginaw.*

"cottages" where people could spend the day fishing and picnicking along the riverfront in floating recreational communities.

Before World War I, the Saginaw River was a popular fishing and hunting destination for sportsmen who used houseboats as seasonal accommodations. As Saginaw headed into the twentieth century, its recreational waterfront became dominated by industrial sites and factories. Houseboats and raft dwellings went from temporary to permanent housing for factory workers and impoverished "river people," who found a way to live on the river year round. The river became increasingly polluted. For decades, the city dumped raw sewage into the river, and the river people continued the practice until the mid-twentieth century, when the city cleaned up its act and houseboats were condemned and removed. Still, as late as the 1970s, Dow Chemical Company, General Motors and other factories were dumping industrial toxins into the river, requiring a major environmental cleanup that continues today.[151]

DIXIE COMES TO MICHIGAN

One of the outcomes of the Good Roads movement was that in the 1910s, private automobile associations formed to advocate the use of automobiles for recreation and to promote driving for enjoyment. The lack of good roads was a major problem, so motoring enthusiasts undertook efforts to establish routes for cross-country travel. Decades before there was any sort of interstate highway system, these designated routes encouraged travelers to see the country from their automobiles, and the idea caught on. A new kind of accommodation—the motel—sprang up along these routes to capture vacationing automobile traffic. Two famous routes were the Lincoln Highway, which navigated coast to coast, and the Dixie Highway, so called because it looped around the state of Florida before leading north

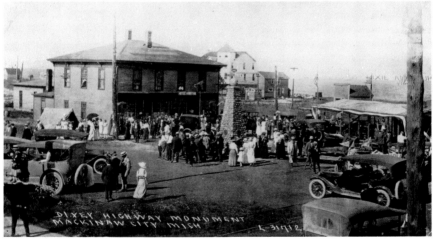

Top: In 1922, an automobile tourism effort created cross-country highway systems such as the Dixie Highway, which incorporated the Woodward-Saginaw corridor, parts of which still bear the Dixie name. *Chattanooga Public Library.*

Bottom: The terminus of the Dixie Highway at Mackinaw City promised to bring a whole new generation of auto tourists and greater prosperity to this small town in the shadow of Mackinac Island. *Mackinaw Area Public Library, Marsh Collection.*

around the coast of Michigan and back down south. The Dixie Highway incorporated some of the oldest roads in the country. In Michigan, they followed the routes of old Indian trails, especially the Woodward Avenue/ Saginaw Highway corridor and then north to Mackinaw City, the terminus for the Dixie Highway in 1921. The opening of the highway put small towns on the map. But more importantly, it ushered in the era of American auto tourism. The name "Dixie Highway" is still used in sections of the original Saginaw Trail route from Pontiac to Saginaw.

Sunday Driver

The automobile opened up local tourism, too. In the late nineteenth century, the wealthy might occasionally venture into the country for a rustic picnic, but in the early twentieth century, just about everybody could do the same in their automobile. The "Sunday drive" was rooted in the pre-automobile bicycle craze and the Good Roads movement, when traveling local roads for pleasure became part of everyday culture.[152] In the 1920s, Oakland County's Road Commission had an organized and well-funded system for improving roads with gravel and pavement. The beautiful scenery, lakes, picnic sites and quality of the roads were promoted by the commission to the general public, who were invited to take advantage of recreational opportunities not far off the Woodward corridor. At the time, many of Oakland County's lakes had accessible waterfronts sprinkled with cabin resorts, cottages and parklike frontage. But with good road access to the lakes, they became desirable home sites, soon limiting public waterfront access. Today, the numerous lakes of southeast Michigan continue to be magnets for weekend recreation. The old Saginaw Trail route still follows some of the most beautiful landscape in southeast Michigan.[153]

In the two centuries since pioneers trudged and struggled to follow the Saginaw Trail, the people of Michigan have come full circle in what the trail meant to them then and what they value now. Although homesteaders wanted to banish the wilderness, modern Michiganders want to preserve it. What settlers wanted to dominate, we seek to celebrate.

The Woodward Avenue that Judge Woodward laid out and aligned with the stars; the trail followed by Oliver and Alpheus Williams and their wives to their wilderness paradise; the mucky forest trail that Stephen Mack followed

A Sunday drive in the countryside drew pleasure-seeking picnickers to a new resource in Oakland County—its natural beauty. *Oakland County Pioneer and Historical Society.*

Lakes that were once an impediment to farming became recreational destinations in the early twentieth century. Summer cottages became commonplace on nearly every lake in Oakland County. *Oakland County Pioneer and Historical Society.*

Local auto tourism was promoted to enjoy natural scenery such as this "charming forest" roadway in Oakland County. Less than a century earlier, that same forest had been an enemy. *Oakland County Pioneer and Historical Society.*

to visit the new town site of Pontiac; the path Lewis Cass and his entourage took to meet the Saginaw Chippewa and that the fierce Kishkawko followed to torment the white settlers; the corduroy road Elizabeth Forth traveled to see her new land in Pontiac; the quiet trail at the Flint River where Jacob Smith slept his last sleep; the mosquito-infested wetlands that drove the soldiers from Fort Saginaw; the stately forest that inspired melancholy in Tocqueville; the wild landscape, the fish and birds, the wolves, the frozen waters, the disappearing Indian presence on the old path—all these and more are part of the legacy of the Saginaw Trail and lie just below the surface of the pavement of Woodward Avenue.

NOTES

Introduction

1. Albert and Comer, *Atlas of Early Michigan's Forests*, vii–xxviii.
2. Kapp, "Michigan Late Pleistocene," 31–58.
3. Ashley Hessel, "Bi-faces from Oakland County," e-mail message to author, April 15, 2015.

Part I

4. Tocqueville, *Journey to America*, 354, 377.

Chapter 1

5. Blowe, *Geographical, Historical, Commercial, and Agricultural View*, 98–100.
6. Chardavoyne, *Hanging in Detroit*, 77.
7. Seeley, *History of Oakland County*, 287; Burton, *History of Detroit*, 74–78.
8. Kappler, "Treaty with the Ottawa," Article 5, 92–93.
9. Thomas, *Members of the Society of the Cincinnati, Original*, 7–8, 39.
10. Detroit Historical Society, "Hull, William."
11. Look, "Lewis Cass," 22–29.

Chapter 2

12. Burton, Stocking and Miller, *History of Detroit*, 1439.
13. Wood, *Dictionary of Quotations*, 410.
14. Bald, *Great Fire of 1805*.

15. Parke, "Reminiscences," 572–92.
16. Roberts, "Detroit: Sketches," 530–36; Burton, Stocking and Miller, *History of Detroit*, 154–55.
17. Farmer, *History of Detroit*, 134–35.
18. Catlin, *Story of Detroit*, 134.
19. Donovan, "Sibley, Solomon."
20. Seeley, *History of Oakland County*, 89–90, 286–88.
21. Klunder, *Lewis Cass*, 39–40.
22. Littlejohn, "Slaves, Judge Woodward," 22-25; Swan, *Lisette*, 7–53.
23. Pielack, "Elizabeth (Lisette) Denison (Forth)."

Chapter 3

24. Schaetzl, "Tiffin Report."
25. Fuller, "Settlement of Michigan Territory," 25–55.
26. Lewis, *West to Far Michigan*, 56–57; Schaetzl, "Early Impressions of Land."
27. Lewis, *West to Far Michigan*, 121–26.
28. Perkins, *Royal Oak*, 5–9.
29. *Detroit Gazette*, "View of Some of the Lands."
30. Bidlack, "Judge Woodward's 'Narrative,'" 43–54.
31. Fuller, "Settlement of Michigan Territory," 30.
32. Bidlack, "Judge Woodward's 'Narrative,'" 48–50.
33. Catlin, *Story of Detroit*, 231; FamilySearch, "Stephen Mack."
34. Au, "'Best Troops in the World.'"
35. Catlin, *Story of Detroit*, 231; FamilySearch, "Stephen Mack."
36. Backman, "Awakenings in the Burned-Over District."
37. Jorgensen, "History of Benjamin Covey."

Chapter 4

38. Fuller, "Settlement of Michigan Territory," 25–55; Lewis, *West to Far Michigan*, 103–41.
39. Schaetzl, "Settlement of Michigan."
40. *Detroit Gazette*, "View of Some of the Lands."
41. U.S. Department of the Interior, "Oakland County, Michigan." Users can access original survey plats and the associated land records.
42. Birth records of the Willits siblings suggest the family left Pennsylvania for Upper Canada (Ontario) after 1798 but were in Detroit sometime after 1806. Willits's parents died in Grosse Pointe, Wayne County, in 1829 and 1830. Geni. com, "Mary Willits (Allison)."
43. Burton, Stocking and Miller, *History of Detroit*, 1477–79.
44. *Biographical History of Genesee County*, 175; Williams, "Personal Reminiscences," 233–59.

45. Hamilton became well known in the transportation business in early Birmingham, initially for providing cartage for pioneers migrating to the interior from Detroit up the trail. Soon he was taking transportation contracts for the U.S. military and in the 1830s further expanded into the stagecoach business between Detroit and Chicago. The flood of eastern migrants going to Chicago at the time and early government-funded road improvements for the Chicago Road route made the stage transportation business especially lucrative. Quaife, *Chicago's Highways*, 40–41.

46. Lewis, *West to Far Michigan*, 130–35.

47. McMechan, *Book of Birmingham*, 25–40; U.S. Department of the Interior, "Oakland County, Michigan," DM 26447.

48. In his haste, Hunter built his first cabin on the wrong side of the line on Willits's land, so he had to build another soon after. Durant, *History of Oakland County*, 267, 318, 322; Burton, Stocking and Miller, *History of Detroit*, 1478.

49. Pielack, "Clash of Cultures."

50. *Detroit Gazette*, April 12, 1825, transcription of original article about Utter murders, Birmingham Museum.

51. *State of Michigan v. Emri Fish.*

Chapter 5

52. Haas, "History of Our Lakes," 73.

53. Cleland, *Rites of Conquest*, 150–60.

54. Lewis, *West to Far Michigan*, 87.

55. Markham, "Early History of the Township of Plymouth," 553.

56. Williams, copy of letter to Henry M. Look, 49–51.

57. Lewis, *West to Far Michigan*, 66–67.

58. Williams, "Personal Reminiscences," 256.

59. Drake, "Oakland County History," 565–66; Williams, "Personal Reminiscences," 233–34.

60. Williams, "Biographical Sketches," 194.

61. Ellis, *History of Shiawassee*, 159; Williams, "Personal Reminiscences," 237–38.

62. Ellis, *History of Shiawassee*, 158–59; Williams, "Personal Reminiscences," 233–34; Michigan Maritime Museum, "Friends Good Will."

63. Lossing, *Pictorial Field Book*, 529.

64. Gardner, Ephraim, B.O. (Benjamin) and Alfred Williams became fur traders who were instrumental in the successful settlement and growth of the Shiawassee River Valley and the establishment of the town of Saginaw. Williams, "Personal Reminiscences," 233–59; Ellis, *History of Shiawassee*, 120, 158–59.

65. Tocqueville, *Journey to America*, 372.

66. Although usually translated as "the Crow," a more accurate translation seems to be "the Raven." Vogel, *Indian Names*, 30.

67. Crawford, *Daring Trader*, 249; Tanner, *Narrative of the Captivity*, 25–35.

68. Dustin, "Treaty of Saginaw," 243–77.

69. Tocqueville, *Journey to America*, 372; Hodges and Williams, "Major Oliver Williams," 300–3. Williams's generosity with Kishkawko was quickly followed by an appeal to Governor Cass for funds to replace the crops Williams needed to feed his family that winter. Crawford, *Daring Trader*, 184.

70. Catlin, *Story of Detroit*, 278; Williams, "Personal Reminiscences," 246; *Detroit Gazette*, January 10, 1826.

Chapter 6

71. Catlin, *Story of Detroit*, 281–82.

72. Quaife, *Chicago's Highways*, 177–79; State of Michigan, "Act to Regulate Taverns," 407–12.

73. State of Michigan, "Act to Establish a Certain Road," 311–12.

74. *Detroit Gazette*, "Pontiac Road"; Parke, "Reminiscences," 573–77; Szewczyk, "Radial Avenues."

75. McMechan, *Book of Birmingham*, 67–68. A letter from Andrew Whitney dated January 10, 1819, describes these events to William Woodbridge, the Michigan territorial representative in Washington; see Burton, *History of Detroit*, 74–76.

76. Burton and Burton, *Governor and Judges Records*, 228.

77. Records and snapshots of this Native American trail marker, or "twisted" tree, can be seen at the Royal Oak Historical Society Museum.

78. Baldwin purchased his land in October 1819, before the final commission report. Cook was party to a land purchase in Section 5 of Royal Oak Township. Farmer, *History of Detroit*, 770; Seeley, *History of Oakland County*, 236–37; U.S. Department of the Interior, "Oakland County, Michigan," #592.

79. Szewczyk, "Radial Avenues."

80. Perkins, *Royal Oak*, 20–21.

81. U.S. Department of the Interior, "Oakland County, Michigan," #10232, #10300; Burton, Stocking and Miller, *History of Detroit*, 1368–69.

82. Bolcevik, "Rhetoric and Realities," 86–90, 107–9.

83. Burton, *History of Detroit*, 1369; Castle, "Traveling on Foot"; Perkins, *Royal Oak*, 20–21, 27.

84. Parker, "Royal Oak," 37; Mull, *Underground Railroad in Michigan*, 28.

85. Perkins, *Royal Oak*, 61–62.

86. McMechan, *Book of Birmingham*, 30–31.

Chapter 7

87. State of Michigan, Water Resources Division, "Michigan's Major Watersheds."

88. Hinsdale, *Archaeological Atlas of Michigan*, 6–10, Maps 2, 6 and 9.

89. Anishnaabeg is the plural of Anishnaabe, which roughly translates to "the original people." Cleland, *Rites of Conquest*, 39–40, 50–51, 192–94.

90. Ibid, 58–60; World Library, "Anishnaabe Clan System."

91. Eric Hemenway, personal communication, 2015.

92. A heartbreaking story relates to a band of Potawatomi that tried to evade forced removal from Shiawassee County in 1840. They were rounded up by government troops, confined under guard and then rolled away in wagons west of the Mississippi, far from their ancestral homelands in Michigan. *Past and Present of Shiawassee County*, 8–9.

93. Cleland, *Rites of Conquest*, 198–263.

94. Turner, "Chief Okemos," 156–59; *Past and Present of Shiawassee County*, 7, 28–34; Cleland, *Rites of Conquest*, 136–37.

95. Lossing, *Pictorial Field Book* , 48; *Past and Present of Shiawassee County*, 28–34; Vogel, *Indian Names*, 34; National Park Service, "Chief Okemos."

96. *Past and Present of Shiawassee County*, 28–34; *History of St. Clair County*, "Okemos," 188–89.

97. Williams, "Remembrances of Early Days," 137–41; Brainard, *Pioneer History*; Ellis, *History of Genesee County*, 238–40; Felt, "Incidents of Pioneer Life," 288–95.

98. Williams, "Remembrances of Early Days," 138.

99. Ellis, *History of Genesee County*, 238–40; Felt, "Incidents of Pioneer Life," 292.

100. Williams, "Remembrances of Early Days," 137–38; Brainard, *Pioneer History*, 38.

101. Williams, "Remembrances of Early Days," 140; Crawford, *Daring Trader*, 205. Another large stone on a hill in the Plymouth, Michigan area associated with the Potawatomi tribe was reportedly revered in a similar way and also called by the same name, "Bab-o-quah." McDonald, "Inquiry into Plymouth History."

102. Williams, "Remembrances of Early Days," 140.

103. Kishkawko realized that the surveyors spelled doom for the Saginaw Chippewa and tried to obstruct them in their work at Saginaw. Crawford, *Daring Trader*, 188–89.

104. Parke, "Reminiscences," 583.

105. Ibid., 572–91.

Chapter 8

106. Crawford, *Daring Trader*, 12–15, 170–71.

107. Ibid., 18, 20–23, 180–81, 215.

108. *Past and Present of Shiawassee County*, 13–18.

109. Williams, "Shiawassee County," 475–88; Ellis, *History of Shiawassee*, 111–12.

110. *Past and Present of Shiawassee County*, 18–19, 28.

111. Crawford, *Daring Trader*, 220; Ellis, *History of Genesee County*, 117; *Art Work of Genesee*, 44.

112. *Biographical History of Genesee County*, "William McGregor," 81–82.

Chapter 9

113. *Chimookamun* translates to Long Knife, an old reference to Americans that was still used in the early nineteenth century, appearing under various spellings. Dustin, "Treaty of Saginaw," 245.
114. Crawford, *Daring Trader*, 118–19.
115. Dustin, "Saginaw County as a Center," 256–58.
116. Dustin, "Treaty of Saginaw," 249–50.
117. Vogel, *Indian Names*, 138–39; Mason, *Struggle for Survival*, 29; Dustin, "Treaty of Saginaw," 244; *Past and Present of Shiawassee County*, 2; Williams, "Legends of Indian History," 134–36.
118. Prucha, *Lewis Cass and American Indian Policy*, 1–14.
119. Dustin, "Treaty of Saginaw," 258–59.
120. Ogemakeketo, addressing Lewis Cass at Treaty of Saginaw, as quoted by Williams, "Treaty of Saginaw," 264.
121. Keenan, "Legacies of Isabella County."
122. Whiting, "Dr. J.L. Whiting's Historic Sketch," 460–62; Fox, "Kish-kaw-ko Again," 78–79; Ellis, *History of Genesee County*, 239.
123. Some images of David Shoppenagon at the Clarke Historical Library are variously labeled "Chap-ne-gance" and "Chap-ne-gosh, 'Little Needle,'" see images 4-794/3065; Hendershot, "Legacy of an Ojibwe 'Lumber Chief,'" 241–69; Greenman, "Chieftainship among Michigan Indians," 367; Historical Michigan Calendar, "December 25 (David Shoppenagon)."

Part II

124. Tocqueville, *Journey to America*, 399.

Chapter 10

125. Mills, *History of Saginaw County*, vol. 1, 704.
126. Leeson and Clarke, *History of Saginaw County*, 197, 382–83; Mills, *History of Saginaw County*, vol. 2, 304.
127. Thomas and Galatian, "History of East Saginaw," 4; Mills, *History of Saginaw*, vol. 1, 705.
128. Leeson and Clarke, *History of Saginaw County*, 178–79, 296–98, 385, 390–92, 404, 412–14.
129. Ibid., 295–97, 412–14, 415–17.
130. Mills, *History of Saginaw County*, vol. 1, 440, 503–6.

Chapter 11

131. Leeson and Clarke, *History of Saginaw County*, 442–43.
132. Pohl and Brown, "History of Roads in Michigan."
133. Leeson and Clarke, *History of Saginaw County*, 287–88; Thompson, "Bay City Land Dredge," 21–43.
134. Mills, *History of Saginaw County*, vol. 1, 694.
135. Ibid., 693–97; Leeson and Clarke, *History of Saginaw County*, 296–97; Mahar, "History of Michigan's Beet Sugar Industry."

Chapter 12

136. Lewis, *West to Far Michigan*, 153–78.
137. Atack, Bateman and Margo, "Steam Power," 2–10.
138. Lewis, *West to Far Michigan*, 127–29; Durant, *History of Oakland County*, 35.
139. Schaetzl, "History of Agriculture in Michigan."
140. Shiawassee History, "Owosso Speedway and 'Prisoner of War' Camp History"; Hall, *Michigan Historical Review*, 57–79.
141. Lazovic, "Rise and Fall of Flint."
142. Meyer, "Degradation of Work Revisited."
143. Bentley Public Library, Finding Aid and Research Guide, "Automotive History," 3.
144. A fascinating industry journal, *The Horseless Age*, captures the atmosphere of the excitement and development of ideas in the fledgling auto industry. See, for example, *The Horseless Age* 21, no. 1 (January 1908), books.google.com/books?id=2GY6AQAAMAAJ.
145. Sonnenberg, "History of Cars"; Mills, *History of Saginaw County*, vol. 1, 536–42; Gustin, "Spark that Created GM"; Bowman, "Oakland Motor Car Company"; Brazeau, "Rapid Trucks"; Anderson, "Wheels for the World."

Chapter 13

146. Oakland County Road Commission, "Oakland Highways," 95–97.
147. The Detroit United Railway (DUR) was promoted by developers of a subdivision for economical auto worker housing along Woodward in Birmingham called Eco-City. Ads touted that the housing was ideally located halfway between Detroit and Pontiac and just a few minutes' ride by DUR line to auto plants in either direction (Birmingham Museum).
148. "Wider Woodward Avenue Project," *Michigan Roads and Forests*, 6.
149. Oakland County Road Commission, "Oakland Highways," 8–9.
150. Bessert, "Zilwaukee Bridge."

Chapter 14

151. Engel, "River People Once Lived on Waterway"; Foote, "Michigan Fish and Game," 340–42; U.S. Environmental Protection Agency, "Superfund Site: Tittabawassee River."
152. U.S. Department of Transportation, "Why Do People Like to Drive?"
153. Oakland County Road Commission, "Oakland Highways," 56–67.

BIBLIOGRAPHY

Albert, Dennis A., and Patrick J. Comer. *Atlas of Early Michigan's Forests, Grasslands and Wetlands: An Interpretation of the 1816–1856 General Land Office Surveys.* East Lansing: Michigan State University Press, 2008.

Anderson, Matt. "Wheels for the World: Michigan's Automotive Industry." October 19, 2016. www.michigan.gov/documents/mdot/19_Wheels_for_World_MI_Automotive_History_540400_7.pdf.

Art Work of Genesee and Shiawassee Counties. Chicago: W.H. Parish, 1894. mmm.lib.msu.edu/record.php?id=237.

Atack, Jeremy, Fred Bateman and Robert Margo. "Steam Power, Establishment Size, and Labor Productivity Growth in Nineteenth Century American Manufacturing." *National Bureau of Economic Research Working Paper Series* #11931 (January 2006). www.nber.org/papers/w11931.

Au, Dennis M. "'Best Troops in the World': The Michigan Territorial Militia in the Detroit River Theater During the War of 1812." Selected Papers from the 1991 and 1992 George Rogers Clark Trans-Appalachian Frontier History Conferences. npshistory.com/series/symposia/george_rogers_clark/1991-1992/sec7.htm.

Backman, Milton V. "Awakenings in the Burned-Over District: New Light on the Historical Setting of the First Vision." Religious Studies Center, Brigham Young University Religious Education. rsc.byu.edu/archived/exploring-first-vision/4-awakenings-burned-over-district-new-light-historical-setting-first.

Bald, Clever F. *The Great Fire of 1805.* Detroit, MI: Wayne University Press, 1951.

Bentley Public Library, University of Michigan. "Automotive History." Finding Aid and Research Guide. bentley.umich.edu/wp-content/uploads/2014/09/Automotive_History_Subject_Guide.pdf.

Bessert, Christopher J. "Zilwaukee Bridge: From the Beginning." Michigan Highways: The Great Routes of the Great Lake State. www.michiganhighways.org/indepth/zilwaukee_report10.html.

Bidlack, Russell, ed. "Judge Woodward's 'Narrative of a Recent Exploring Party in the Michigan Territory.'" *Quarterly Review: A Journal of University Perspectives* 66 (1959): 43–54. books.google.com/books?id=uRlYAAAAMAAJ.

Biographical History of Genesee County, Michigan. Indianapolis: B.F. Bowen, 1908.

Blowe, Daniel. *A Geographical, Historical, Commercial, and Agricultural View of the United States of America; Forming a Complete Emigrants Directory.* London: Edwards and Knibb, 1820. books.google.com/books?id=-2xKAAAAMAAJ.

Bolcevik, Sherri Q. "Rhetoric and Realities: Women, Gender, and War in the War of 1812 in the Great Lakes Region." Master's thesis, Bowling Green University, 2015. etd.ohiolink.edu/!etd.send_file?accession=bgsu1407847108&disposition= inline.

Bowman, Bill. "The Oakland Motor Car Company." GM Heritage Center. history. gmheritagecenter.com/wiki/index.php/Oakland_Motor_Car_Company.

Brainard, Alvah. *A Pioneer History of the Town of Grand Blanc, Michigan.* Flint, MI: Globe Power Press, 1878. name.umdl.umich.edu/5423839.0001.001.

Brazeau, Mike. "Rapid Trucks." GM Heritage Center. history.gmheritagecenter. com/wiki/index.php/Rapid_Trucks.

Burton, Agnes M., and Clarence M. Burton. *Governor and Judges Records: Proceedings of the Land Board of Detroit.* Detroit: Michigan Commission on Land Titles, 1915, 228.

Burton, Clarence M. *History of Detroit, 1780–1850: Financial and Commercial.* Detroit, MI: self-published, 1917.

Burton, Clarence M., ed., with William Stocking and Gordon Miller, joint eds. *History of Detroit, Michigan: 1701–1922.* Vol. 2. Detroit, MI: S.J. Clarke, 1922.

Castle, Norman. "Traveling on Foot." Transcript of letter to R.A. Parker, 1830, Birmingham Museum Collection.

Catlin, George. *The Story of Detroit.* Detroit, MI: Detroit News, 1926.

Chardavoyne, David D. *A Hanging in Detroit: Stephen Gifford Simmons and the Last Execution Under Michigan Law.* Detroit, MI: Wayne State University Press, 2003. books.google.com/books?isbn=0814337392.

Cleland, Charles. *Rites of Conquest: The History and Culture of Michigan's Native Americans.* Ann Arbor: University of Michigan Press, 1992.

Crawford, Kim. *The Daring Trader: Jacob Smith in the Michigan Territory, 1802–1825.* East Lansing: Michigan State University Press, 2012.

Detroit Gazette, April 12, 1825. Transcription of article, Birmingham Museum.

———. January 10, 1826. news.google.com/newspapers?nid=scjTk0LcRdsC&dat =18260110&printsec=frontpage&hl=en.

———. "The Pontiac Road." November 10, 1820. news.google.com/ newspapers?nid=scjTk0LcRdsC.

———. "A View of Some of the Lands in the Interior of the Territory of Michigan." November 13, 1818. news.google.com/newspapers?nid=scjTk0LcRdsC&dat=1 8181113&printsec=frontpage&hl=en.

Detroit Historical Society, Encyclopedia of Detroit. "Hull, William." detroithistorical. org/learn/encyclopedia-of-detroit/hull-william.

Donovan, Andrew. "Sibley, Solomon." Detroit Historical Society: Encyclopedia of Detroit. detroithistorical.org/learn/encyclopedia-of-detroit/sibley-solomon.

Drake, Thomas J. "Oakland County History." *Michigan Pioneer and Historical Collections* 3 (1881): 559–71.

Durant, Samuel W. *History of Oakland County.* Philadelphia: L.H. Everts, 1877.

Dustin, Fred. "Saginaw County as a Center of Aboriginal Population." *Michigan Historical Collections* 34 (1915): 251–62. books.google.com/books?id=VKEfAQAAMAAJ.

———. "The Treaty of Saginaw, 1819." *Michigan History Magazine* 4 (1920): 243–77. books.google.com/books?id=LhMUAAAAYAAJ.

Ellis, Franklin. *History of Genesee County, Michigan.* Philadelphia: Everts and Abbott, 1879. name.umdl.umich.edu/BAD0919.0001.001.

———. *History of Shiawassee and Clinton Counties, Michigan.* Philadelphia: D.W. Ensign & Co., 1880. name.umdl.umich.edu/BAD1049.0001.001.

Engel, Justin. "River People Once Lived on Waterway." March 18, 2011. mLive. www.mlive.com/news/saginaw/index.ssf/2011/03/river_people_once_lived_on_sag.html.

FamilySearch. "Stephen Mack (1766–1826)." April 23, 2013. familysearch.org/photos/artifacts/821513.

Farmer, Silas. *The History of Detroit and Michigan; or, The Metropolis Illustrated.* Detroit, MI: Silas Farmer & Co., 1889.

Felt, Alizina Calkins. "Incidents of Pioneer Life." *Michigan History* 6 (1922): 288–95. books.google.com/books?id=0qA_AQAAMAA.

Foote, L.S. "Michigan Fish and Game." *American Angler* 2 (1917): 340–42. books.google.com/books?id=fXEXAAAAYAAJ.

Fox, Truman B. "Kish-kaw-ko Again." In *History of Saginaw County from the Year 1819 Down to the Present.* East Saginaw, MI: Enterprise Print, 1858, 78–79. books.google.com/books?id=58ziAAAAMAAJ.

Fuller, George N. "Settlement of Michigan Territory." *Mississippi Valley Historical Review* 2, no. 1 (1915): 25–55. www.jstor.org/stable/1889104.

Geni.com. "Mary Willits (Allison)." www.geni.com/people/Mary-Willits/6000000000117903806.

Greenman, Emerson. "Chieftainship among Michigan Indians." *Michigan History* 24 (1940): 361–79. turtletalk.files.wordpress.com/2007/12/chieftianship-among-michigan-indians.pdf.

Gustin, Lawrence. "The Spark that Created GM: Billy Durant Takes Control of Buick." 2006. GM Heritage Center. history.gmheritagecenter.com/wiki/index.php/The_spark_that_created_GM:_Billy_Durant_takes_control_of_Buick.

Haas, Joe. "History of Our Lakes." *Oakland Press* (Pontiac, MI), January 3, 1947. In *Beardslee Scrapbook.* Vol. 2. Oakland County Pioneer and Historical Society.

Hendershot, Robert. "The Legacy of an Ojibwe 'Lumber Chief,' David Shoppenagon." *Michigan Historical Review* 29 (2003): 241–69.

Hinsdale, Wilbert. *Archaeological Atlas of Michigan.* Ann Arbor: University of Michigan Press, 1931.

Historical Michigan Calendar, Clarke Historical Library. "December 25 (David Shoppenagon)." www.cmich.edu/library/clarke/ResearchResources/Michigan_

Material_Statewide/MichiganHistoricalCalendar/Pages/12_december/December-25.aspx.

History of St. Clair County, Michigan. "Okemos." Chicago: A.T. Andreas, 1883. name. umdl.umich.edu/arx2236.0001.001.

Hodges, Mary Ann, and B.O. Williams. "Major Oliver Williams and Family." In *History of Oakland County*, by Samuel W. Durant. Philadelphia: L.H. Everts, 1877, 300–3.

Jorgensen, Grace Covey. "History of Benjamin Covey and Almira Mack." FamilySearch, June 9, 2014. familysearch.org/photos/artifacts/7736605.

Kapp, Ronald O. "Michigan Late Pleistocene, Holocene, and Presettlement Vegetation and Climate." In *Retrieving Michigan's Buried Past: The Archaeology of the Great Lakes State*, edited by John R. Halsey. Bloomfield Hills, MI: Cranbrook Institute of Science, 1999.

Kappler, Charles, ed. "Treaty with the Ottawa, Chippewa, Wyandot, and Potowatomi Indians, November 17, 1807." *Indian Affairs: Laws and Treaties* 2 (1904 reprint). Washington, D.C.: Government Printing Office, 1972. books.google.com/books?id=kgsuAAAAIAAJ.

Keenan, Hudson. "Legacies of Isabella County's Early Indian Reservation 1855–1872." Clarke Historical Library, Native American Resources. www.cmich.edu/library/clarke/ResearchResources/Native_American_Material/Isabella_County_Indian_Reservation/Pages/default.aspx.

Klunder, Willard Carl. *Lewis Cass and the Politics of Moderation.* Kent, OH: Kent State University Press, 1996. books.google.com/books?isbn=0873385365.

Lazovic, Brandon. "The Rise and Fall of Flint, Michigan, from the 1800s." *Odyssey*, February 17, 2016. www.theodysseyonline.com/rise-fall-flint-michigan-beginning-1800s.

Leeson, Michael A., and Damon Clarke. *History of Saginaw County, Michigan.* Chicago: Chas. C. Chapman, 1881. name.umdl.umich.edu/BAD1164.0001.001.

Lewis, Kenneth E. *West to Far Michigan: Settling the Lower Peninsula, 1815–1860.* East Lansing: Michigan State University Press, 2002.

Littlejohn, Edward J. "Slaves, Judge Woodward and the Supreme Court of the Michigan Territory." *Michigan Bar Journal* (July 2015): 22–25. www.michbar.org/file/barjournal/article/documents/pdfarticle2649.pdf.

Look, Henry M. "Lewis Cass." *Freemasons Monthly Magazine* 4 (1873): 22–29. books.google.com/books/about/Freemason_s_Monthly.html?id=O6tLAAAAMAAJ.

Lossing, Benson J. *Pictorial Field Book of the War of 1812.* New York: Harper & Brothers, 1869.

Mahar, Thomas. "History of Michigan's Beet Sugar Industry." April 17, 2010. beetsugarhistory.blogspot.com/2009/06/michigans-saginaw-valley-prairie-farm.html.

Markham, A.B. "Early History of the Township of Plymouth." *Michigan Pioneer and Historical Collections* 2 (1880): 549–67.

Mason, Philip P. *Struggle for Survival: The Story of Michigan's Indians.* Reprinted from *Michigan Conservation* 29 (1960). Detroit Historical Society.

McDonald, Mark. "An Inquiry into Plymouth History: The Mystery of the Black Stone of the Potawatomi." mmcdonald77: Philosophy and Politics. mmcdonald77.wordpress.com/plymouth-history.

McMechan, Jervis B. *The Book of Birmingham.* Birmingham, MI: Birmingham Historical Board, 1976.

Meyer, Stephen. "The Degradation of Work Revisited: Workers and Technology in the Auto Industry from 1900–2000." Automobile in American Life and Society. www.autolife.umd.umich.edu/Labor/L_Overview/L_Overview5.htm.

Michigan Maritime Museum. "Friends Good Will: Her Story." www.michiganmaritimemuseum.org/fgwhistory.

Mills, James C. *History of Saginaw County, Michigan.* Vols. 1–2. Saginaw, MI: Seemann and Peters, 1917–18. name.umdl.umich.edu/BAD1040.0001.001; http://name.umdl.umich.edu/BAD1040.0002.001.

Mull, Carol E. *The Underground Railroad in Michigan.* Jefferson, NC: McFarland & Co., Inc., 2010.

National Park Service, U.S. Department of the Interior. "Chief Okemos." www.nps.gov/people/chief-okemos.htm.

Oakland County Road Commission. "Oakland Highways, 1925: Thirteenth Annual Report." Oakland County Pioneer and Historical Society.

Ogemakeketo. Address to Lewis Cass at Treaty of Saginaw. Quoted in Ephraim S. Williams, "The Treaty of Saginaw in the Year 1819." *Michigan Historical Collections* 7 (1884): 262–70. name.umdl.umich.edu/0534625.0007.001.

Parke, Hervey. "Reminiscences." In *Michigan Pioneer and Historical Collections* 3 (1881): 572–92. books.google.com/books?id=I6cfAQAAMAAJ.

Parker, Ralzemond A. "Royal Oak, Michigan." 1921. Reprinted in *Royal Oak: Twigs and Acorns*, edited by David G. Penney and Lois A. Lance. Royal Oak, MI: Little Acorn Press, 1996.

Past and Present of Shiawassee County. Lansing: Michigan Historical Publishing Association, 1906. name.umdl.umich.edu/4763144.0001.001.

Perkins, Owen. *Royal Oak, Michigan: The Early Years.* Royal Oak, MI: City of Royal Oak, 1971.

Pielack, Leslie. "Clash of Cultures: Mackinac's Benjamin Kendrick Pierce and U.S. Policy after the War of 1812." Unpublished manuscript, 2015.

———. "Elizabeth (Lisette) Denison (Forth)." Nomination, Michigan Women's Hall of Fame, March 17, 2016.

Pohl, Dorothy G., and Norman E. Brown. "History of Roads in Michigan." Reprint of address to Association of Southern Michigan Road Commissions, December 2, 1997. Michigan Highways. www.michiganhighways.org/history2.html.

Prucha, Francis P. *Lewis Cass and American Indian Policy.* Detroit, MI: Detroit Historical Society, 1967.

Quaife, Milo M. *Chicago's Highways Old and New: From Indian Trail to Motor Road.* Chicago: D.F. Keller & Co., 1923.

Roberts, Robert E. "Detroit: Sketches of Its Early History and Leading Political Historical Events." *Michigan Pioneer and Historical Collections* 5 (1884): 530–36. books.google.com/books?id=2hgzAQAAIAAJ.

Schaetzl, Randall J. "Early Impressions of Land (for Agriculture) in Southern Michigan." Geography of Michigan and the Great Lakes Region: A Course at Michigan State University. geo.msu.edu/extra/geogmich/settle.html.

———. "History of Agriculture in Michigan." Geography of Michigan and the Great Lakes Region: A Course at Michigan State University. geo.msu.edu/extra/geogmich/ag_history.htm.

———. "The Settlement of Michigan." Geography of Michigan and the Great Lakes Region: A Course at Michigan State University. geo.msu.edu/extra/geogmich/settlement_of_MI.html.

———. "The Tiffin Report." Geography of Michigan and the Great Lakes Region: A Course at Michigan State University. geo.msu.edu/extra/geogmich/Tiffin.html.

Seeley, Thaddeus D. *History of Oakland County, Michigan: A Narrative Account of Its Historical Progress, Its People and Its Principal Interests.* Chicago and New York: Lewis Publishing Co., 1912.

Shiawassee History. "Owosso Speedway and 'Prisoner of War' Camp History." www.shiawasseehistory.com/prison.html.

Sonnenberg, Mike. "The History of Cars and Trucks Built in Saginaw." *Pure Saginaw*, March 24, 2014. puresaginaw.com/history-cars-trucks-built-saginaw.

State of Michigan. "An Act to Establish a Certain Road." December 7, 1818. *Laws of the Territory of Michigan* 1. Lansing, MI: W.S. George & Co., 1871, 311–12. catalog.hathitrust.org/Record/003931209.

State of Michigan. "An Act to Regulate Taverns." September 10, 1819. *Laws of the Territory of Michigan* 1. Lansing, MI: W.S. George & Co., 1871, 407–12. catalog.hathitrust.org/Record/003931209.

State of Michigan, Water Resources Division. "Michigan's Major Watersheds." www.michigan.gov/documents/deq/lwm-mi-watersheds_202767_7.pdf.

State of Michigan v. Emri Fish. Oakland County, Michigan. County Clerk/Register of Deeds, Legal Records Division, Criminal Records, 1826, A-2/ 60253.

Swan, Isabella E. *Lisette.* Grosse Ile, MI: self-published, 1965.

Szewczyk, Paul. "Radial Avenues, Part II: Woodward." Detroit Urbanism. detroiturbanism.blogspot.com/2016/08/radial-avenues-part-ii-woodward.html.

Tanner, John. *A Narrative of the Captivity and Adventures of John Tanner, during Thirty Years Residence Among the Indians in the Interior of North America.* Edited by Edwin James. New York: G. & C. & H. Carvill, 1830. archive.org/details/cihm_42507.

Thomas, James C., and A.B. Galatian. "History of East Saginaw." *Indian and Pioneer History of Saginaw.* East Saginaw: Lewis and Lyon, 1866. name.umdl.umich.edu/ark3223.0001.001.

Thomas, William Sturgis. *Members of the Society of the Cincinnati, Original, Hereditary and Honorary: With a Brief Account of the Society's History and Aims.* New York: T.A. Wright, Inc., 1929. books.google.com/books?id=wfkQAQAAMAAJ.

Thompson, John. "The Bay City Land Dredge and Dredge Works: Perspectives on the Machines of Land Drainage." *Michigan Historical Review* 12, no. 2 (1986): 21–43. httpwww.jstor.org/stable/20173079.

Tocqueville, Alexis de. *Journey to America*. Translated by George Lawrence and edited by J.P. Mayer, in collaboration with A.P. Kerr. New York: Doubleday & Company, 1971.

Turner, F.N. "Chief Okemos." *Michigan History* 6 (1922): 156–59. catalog.hathitrust. org/Record/008925993.

U.S. Department of the Interior, Bureau of Land Management, General Land Office Records. "Oakland County, Michigan." glorecords.blm.gov/results/default.aspx?s earchCriteria=type=survey|st=MI|cty=125|styp=01.

———. "Oakland County, Michigan." DM 26447. glorecords.blm. gov/details/survey/default.aspx?dm_id=26447&sid=ceqspfo0. aun&surveyDetailsTabIndex=1.

———. "Oakland County, Michigan." #592. glorecords.blm.gov/details/patent/ default.aspx?accession=MI0020__.201.

———. "Oakland County, Michigan." #10232, #10300. glorecords.blm.gov/ details/patent/default.aspx?accession=MI0210__.070.

U.S. Department of Transportation, Federal Highway Administration. "Why Do People Like to Drive for Pleasure? Ask the Rambler." June 27, 2017. Highway History. www.fhwa.dot.gov/infrastructure/scenic.cfm.

U.S. Environmental Protection Agency. "Superfund Site: Tittabawassee River, Saginaw River and Bay: Midland, Michigan." cumulis.epa.gov/supercpad/ cursites/csitinfo.cfm?id=0503250.

Vogel, Virgil J. *Indian Names in Michigan*. Ann Arbor: University of Michigan Press, 1997.

Whiting, J.L. "Dr. J.L. Whiting's Historic Sketch." *Michigan Historical Collections* 2 (1880): 460–62. archive.org/details/michiganhistoric02michuoft.

"Wider Woodward Avenue Project." *Michigan Roads and Forests* 6 (January 1922): 18. books.google.com/books?id=_X7mAAAAMAA.J.

"William McGregor." *Biographical History of Genesee County, Michigan*. Indianapolis: B.F. Bowen, 1908. archive.org/details/bad0918.0001.001.umich.educ.

Williams, B.O. Copy of letter to Henry M. Look. In "Old Oakland County Families," 1945. Oakland County Pioneer and Historical Society Collection.

———. "Shiawassee County." *Michigan Historical Collections* 2 (1901): 475–88. books. google.com/books?id=gBniAAAAMAAJ.

Williams, Ephraim S. "Biographical Sketches: Oliver and Mary Williams." In *Michigan Pioneer and Historical Collections* 10 (1908): 194–209.

———. "Legends of Indian History in the Saginaw Valley." *Michigan Historical Collections* 10 (1908): 134–36. name.umdl.umich.edu/0534625.0010.001.

———. "Personal Reminiscences." *Michigan Pioneer and Historical Collections* 8 (1907): 233–59. name.umdl.umich.edu/0534625.0008.001.

———. "Remembrances of Early Days: Indians and an Indian Trail—A Trip from Pontiac to Grand Blanc and the Saginaws." *Michigan Historical Collections* 10 (1908): 137–42. name.umdl.umich.edu/0534625.0010.001.

———. "The Treaty of Saginaw in the Year 1819." *Michigan Historical Collections* 7 (1884): 262–70. name.umdl.umich.edu/0534625.0007.001.

Wood, James. *Dictionary of Quotations: Ancient and Modern, English and Foreign Sources.* London: Frederick Warne & Co., 1893. archive.org/details/dictionaryquota00woodgoog.

World Library, World Heritage Encyclopedia. "Anishnaabe Clan System." www.worldlibrary.org/articles/anishinaabe_clan_system.

INDEX

ABOUT THE AUTHOR

Leslie K. Pielack is museum director at the Birmingham Museum in Birmingham, Michigan, and has been active in the museum field for many years. She also provides consultation services for historic organizations and archival collections and is past adjunct professor at University of Detroit–Mercy's School of Architecture. Leslie is a dual-career professional with a part-time private practice in counseling as well as her work in public history and preservation. She finds that psychology and historic preservation are very compatible in approaching museum work and is especially intrigued with the personal stories behind historic events and the people who lived them. Her research, writing and presentations draw from these interests in trying to re-create a sense of common ground and connection with people in the past.

Visit us at
www.historypress.net